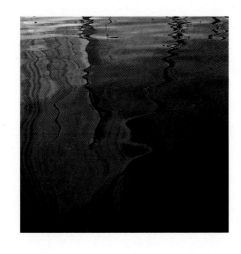

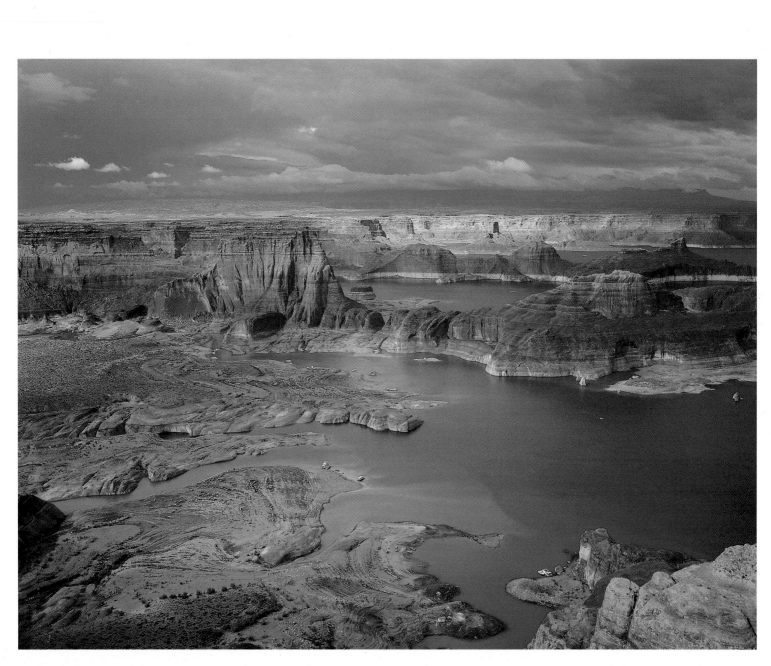

GUNSIGHT CANYON, MAY
*Lake Powell's convoluted bays and nearly two thousand miles
of shoreline host many campers—some in tents, others in
luxurious, floating palaces—on busy weekends.*

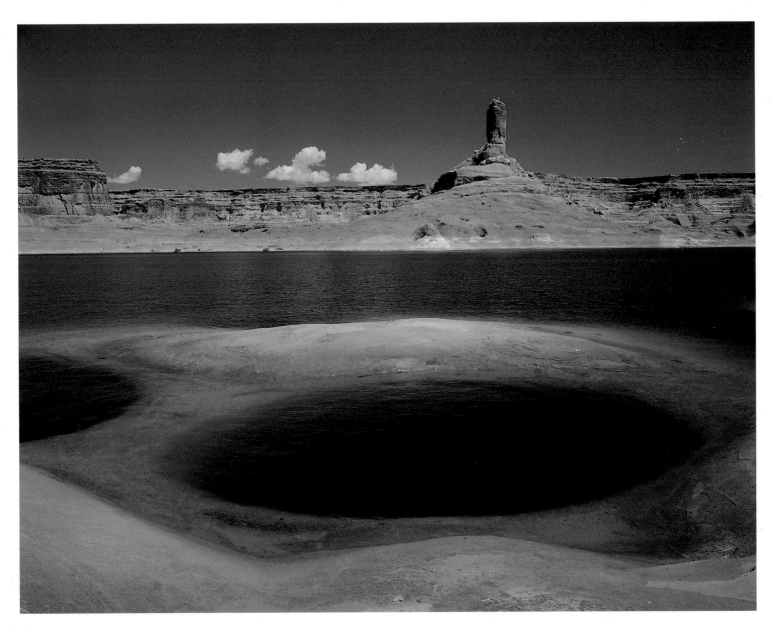

COOKIE JAR BUTTE, SEPTEMBER
In a quiet inlet off Padre Bay, a weathering pit flooded by
Lake Powell forms the shoreline. Geologists continue to
study the mysterious origins of weathering pits.

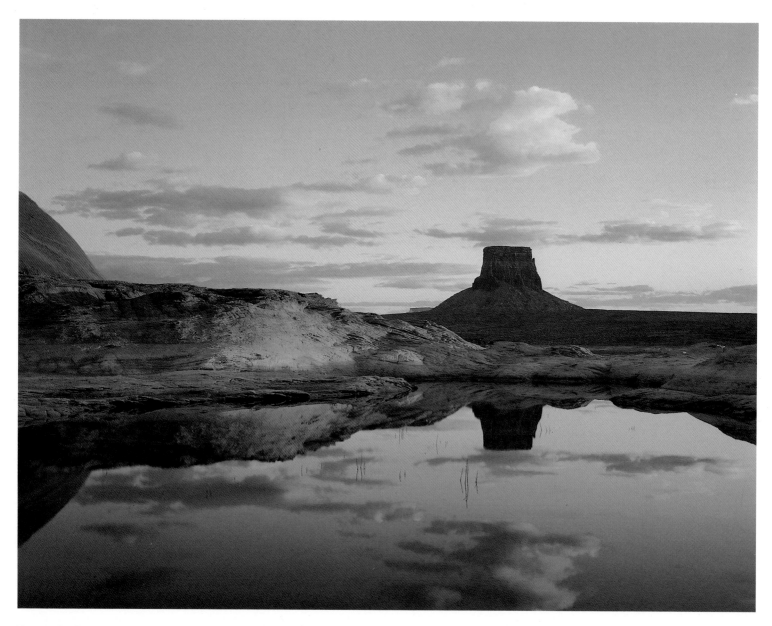

TOWER BUTTE, MARCH
Soft sunset skies and Tower Butte, a landmark on the
Navajo Indian Reservation, reflect in the still waters of Lake Powell.

LAKE POWELL

A PHOTOGRAPHIC ESSAY OF
GLEN CANYON NATIONAL RECREATION AREA

PHOTOGRAPHY BY
GARY LADD

INTERPRETIVE TEXT
BY ANNE MARKWARD

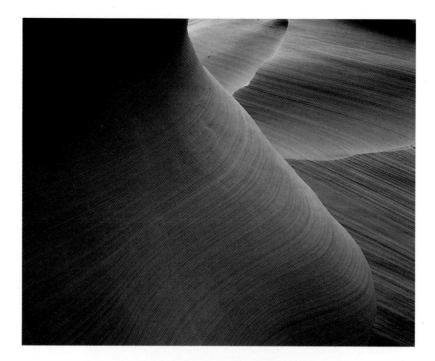

Companion Press
464 Terrace Road
Santa Barbara, California 93109
Jane Freeburg, Publisher/Editor

Designed by Lucy Brown
Editorial Consultant: Mark A. Schlenz

Printed and bound in Korea

ISBN 0-944197-29-9 (paperback)
ISBN 0-944197-30-2 (clothbound)

9 8 7 6 5 4 3 2

For my parents,
Christine and Rolland Ladd,
who—sometimes knowingly—let me
climb to the treetops, range through
the Beaconsfield "forest" and explore
Elmwood Park in Rocky River, Ohio.

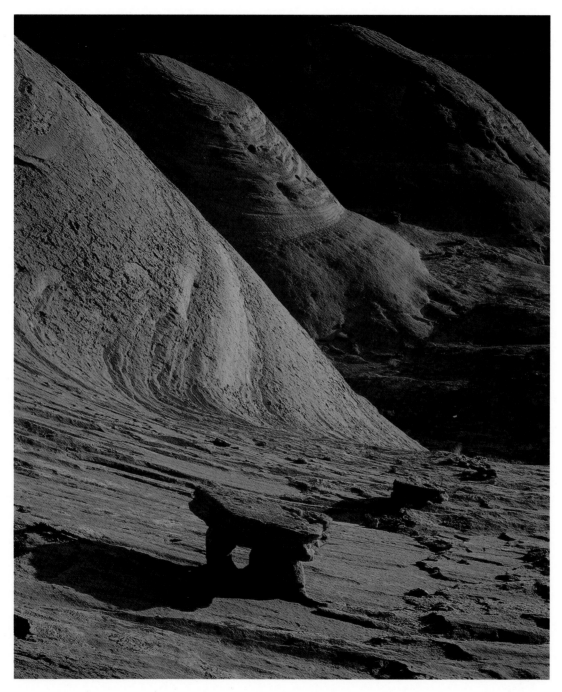

FACE CANYON, AUGUST
*Lake Powell pools in the middle of
a rolling sandstone desert of golden
curves and unexpected balanced rocks.
Weathering processes exploit softer
layers and weaker regions of rock
strata to produce a landscape full
of intriguing surprises.*

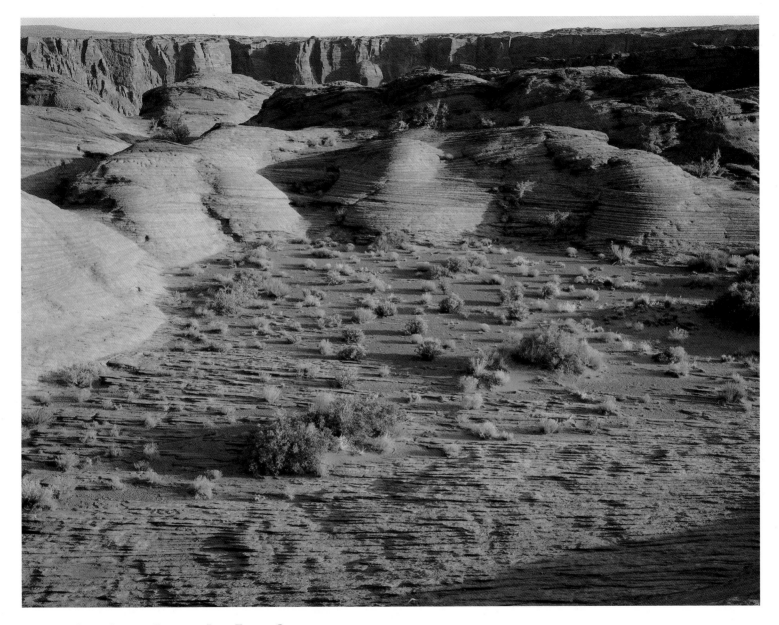

BETWEEN GLEN CANYON DAM AND LEES FERRY, OCTOBER
*Sandy soil has filled this little hollow of rock, allowing hardy plants to root
and grow. The Colorado River sweeps between these softly rounded billows
of sandstone and the straight line of cliffs beyond.*

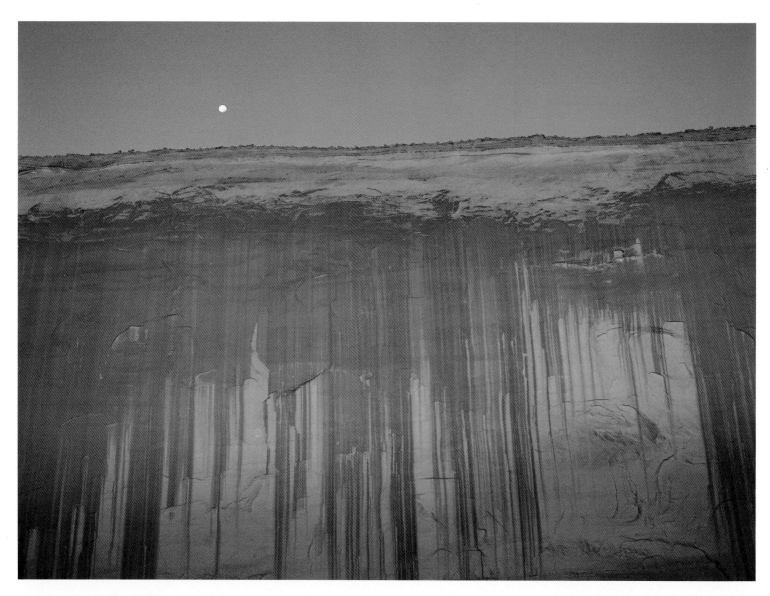

TAPESTRY WALL, SEPTEMBER
*Long ribbons of desert varnish, a mix of iron and
manganese oxides, darkly stain a sandstone cliff face, above.*

TAPESTRY WALL, SEPTEMBER (OPPOSITE)
*The same wall, the same vivid blue sky ripple
in the early morning mirror of Lake Powell.*

10

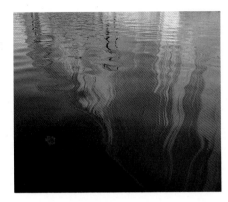

PREFACE

I'm floating in a small boat anticipating sunrise. The sun breaks free of the eastern horizon and the high curving rim of Tapestry Wall ignites. Slick surfaces of Lake Powell reveal fantastic, oscillating patterns of cliff, patina, and sky, an astonishing version of reality. The effect is stunning. So is Lake Powell. But when bubbles, glinting like translucent mercury, rise to the surface, I wonder of their source. What cottonwood, what alcove, what lichen-patterned cliff, what once-fragrant cliffrose now immersed in eternal darkness just sighed in resignation? Neither I nor anyone who arrived after 1963 will ever know.

While ten million tons of concrete hardened near Beehive Rock, a few hundred people—quickened by the inevitable—floated through Glen Canyon to befriend a river under sentence. For many of them it became a period of great joy: exploring a canyon of loveliness, floating a river of legend, passing into enchanted chambers known but to a handful. It ended in great heartache.

In 1963 the patrons of Glen Canyon said goodbye. The gate of the final diversion tunnel slid shut and Lake Powell awakened. Quickly it reached up the Colorado River and crept into a maze of secretive amphitheaters, aisles, slots and side canyons; much of Glen Canyon gagged and drowned. Scientists, historians, photographers, and writers—who had raced the dam to study, record, and celebrate the Canyon—surrendered. New admirers, drawn by the unearthly, almost preternatural lake, inherited a transformed Glen Canyon.

Broken beauty is beauty still. For those who view it today, Lake Powell is a jewel. It echoes pattern and color, adds fresh counterpoint to an ancient terrain of impassive, immovable rock. Glen Canyon Dam provides useful water regulation and electrical generation. Glen Canyon has been developed and made serviceable. But perhaps some restraint is in order: resources, landscapes, even continents, can be improved and enhanced to sad sterility.

The fabled beauty of lost Glen Canyon has grown larger than life, an achievement bordering on the impossible. Its loss has, in a macabre way, magnified rather than reduced its mysterious appeal. The drowned chambers, rippled sandbars, magnificent petroglyph panels, and narrow, shadowy corridors twisting away into the slickrock wilderness whisper to those who know of them. The creation of Lake Powell skewed perceptions and altered logic: those who might naturally champion the surviving canyon ignore and even spurn the enduring glens. To hint of a fondness for the "new" Glen Canyon is regarded as blasphemy.

Rich in sensual curves, flowing forms, and undulating contours, Glen Canyon's sandstones routinely assume the shape of rushing waters, graceful arches, soaring cantilevered cliffs, and fragile, teetering pedestals. Its rocks, stones, cliffs, walls, cobbles, and boulders are habitually polished, fluted, hewn, carved, sculptured, cleaved, and varnished. The Glen Canyon landscape presents a gallery of engravings, magnificent tapestries, seductive sculptures, graphics, and exquisite murals—all in consummate Glen Canyon style.

Whatever your knowledge of Glen Canyon and Lake Powell, don't underestimate them. Glen Canyon was a treasure. It still is. Chambers and niches, overlooked and unnoticed by frantic boaters, disdained by grieving conservationists, are sublime. While backpacking pilgrims prowl and revel in their discoveries, scientists and researchers sift and snoop, unearthing the secrets of the persistent glens, uncloaking a rich and surprising past.

Quite literally, Lake Powell and the surviving canyon are ravishingly beautiful; bizarrely, achingly, unspeakably, paradoxically beautiful.

—Gary Ladd

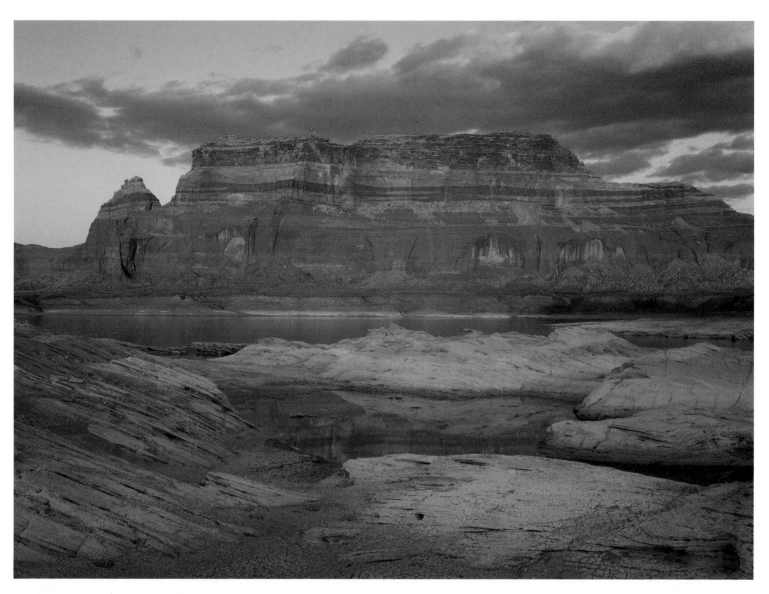

LABYRINTH BAY, MARCH
At sunset, pools of fire reflect the rocks' ochre glow.

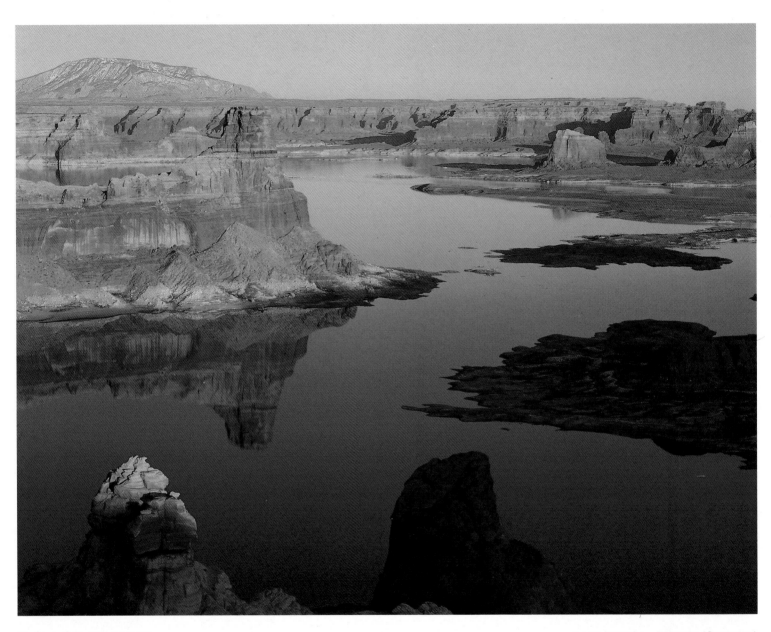

GUNSIGHT BUTTE, MARCH
Neither wind nor wakes mar vast Padre Bay's
mirror on an early spring afternoon, above.

LAKE POWELL, AUGUST (OPPOSITE)
A pebble thrown into still water
sends ripples across a perfect surface.

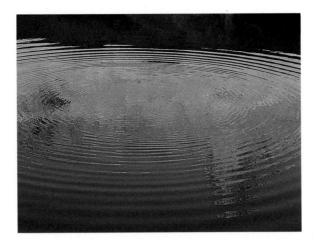

It is reflection that imparts magic to the waters of the Glen Canyon and its tributaries. Every pool and rill, every sheet of flowing water, every wet rock and seep—these mirror with enameled luster the world about.

<div align="right">

ELIOT PORTER
THE PLACE NO ONE KNEW, 1963

</div>

REFLECTIONS

You can almost touch the red rock, almost feel the sandstone's grit. But then the water ripples and the rock undulates away: the mirage broken.

Look into another pool of water. It lies in a slender, somber side canyon where direct light never strikes. Yet glittering gold rims the puddle, refracted from a sun-tipped ridge a thousand feet above. A diffused glow filters down into this narrow corridor, reflecting off one wall, re-reflected off the opposite, then back again—suffusing the whole chamber with a dim, amber blush. The rocks breathe not only heat but rich, vibrant hues of impossible color: salmon tangerines, apricot purples, and coral reds caught forever in a sunless gorge.

In this desert world, light brings inanimate forms to life as surely as any enchantress might. A shimmering wand touches rock and suddenly buttes butt up and buttresses fly, caverns and temples arch overhead, arches bridge into magical kingdoms, and bridges arch over nothingness. The last light fades from the evening sky and the rocks sink into stillness once more, outlined only by the twinkling of stars.

A manmade creation now dominates Glen Canyon. Despite our tinkering, mortals have not entirely broken the magic desert spell. Enchantment

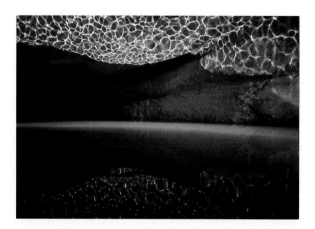

exists still, as surely as the rocks and the light do, and will live on long after
our momentary intrusion.

Humans flooded the main arteries of this magnificent canyon to create
Lake Powell; its waters now pool instead of flow. Boaters bob hundreds of feet
above the natural, desert-varnished cathedrals and vaulting temples that once
enthralled river travellers. High waters instead bring new alcoves and
amphitheatres into view.

The pulses of tributary streams still thrum beyond the lake's body. To
feel their beat, you must indeed leave the main channel. Nudge your boat back
into a narrow side canyon and abandon it. Walk beyond where lake waves lap.
There you will find trickling water polishing streambeds and age-old redbud
trees blossoming each spring.

While human technologies have temporarily re-modeled the canyon,
the canyon has most certainly remolded our ecological consciousness. When
Glen Canyon flooded, conservationists considered it dead. Books and films
eulogized it as "The Place No One Knew." Few Americans had heard of
these remote gullies and ravines; even fewer cared to know what the naked
rocks offered—this part of Utah looked like an empty spot on the map. But the
media attention the damming brought to Glen Canyon, and the millions of
visitors Lake Powell brings to the desert, have helped awaken us to certain
environmental questions and consequences: questions regarding humanity's
prerogative to reshape the world, and the consequences of running out of

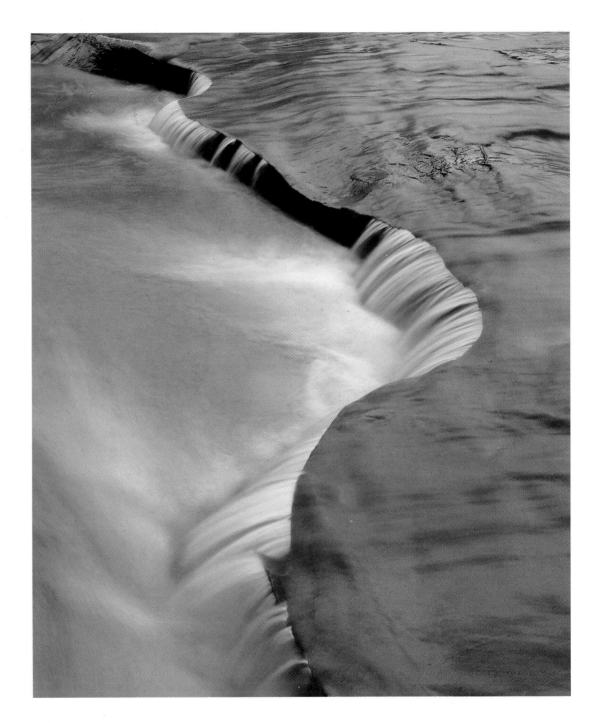

KAIBITO CREEK, JANUARY
Waters tinted molten bronze and cool blue by cliff and sky pour down a sculptured creek bed.

Opposite:
CLEAR CREEK CANYON, MAY
Reflections dance on rock and water. Before lake flooding, this rock alcove soared over the chamber hikers called Cathedral in the Desert, one of the most beautiful places in Glen Canyon.

world to reshape. Public focus has made us more aware of the magnitude of the tradeoffs we face each day when using—and using up—the resources of this finite planet. People continue to air condition their homes and over-water their yards but they have also begun to question the usefulness of building huge, arcing dams, and have grown more reverent of the canyons they drown.

Lake Powell, though an artificial reservoir, still offers some of the same true wild feeling as a lonely desert river. Let it. Beach your boat and climb high above the lake as you look for some of the unnamed, magical scenes in these photographs. Most likely you won't find Gary Ladd's special places—he's spent too many seasons wandering this back country—but in your search you may find other unexpected wonders. Perhaps a hanging garden full of alpine columbine, or a grove of bigtooth maple trees, or a handprint traced onto a rock wall a thousand years ago.

Watch the sun's gold slide along a canyon's wall: down in the morning; up at day's end. Catch sight of tadpoles fluttering in purple-tinted puddles, or caress the soft, polished grooves worn into solid rock by endless waters. Return in fall, when cottonwoods blaze yellow, or in winter, when gentle white drapes over billows of red stone.

Light writes poetry upon this land of rock and water, sand and sage, but not always sweet, flowery verse. Sometimes light scrawls with broad, bold strokes, great blazing heat blaring through the midday sky, scorching and withering even stunted junipers, even the rocks. Sometimes sunbeams lance black boils of storm-tossed clouds with streaks of startling brilliance, etching filigrees of gold and lavender around dark thunderheads. Molten colors layered with leaden shadows stain the cliffs below.

May the enchantress of desert light bring more than landscapes to life. May a sunbeam's magic wand warm you deep inside with those same rich, vibrant colors found in slender gorges. May this canyon and lake and mystical light hold you forever spellbound by desert beauty.

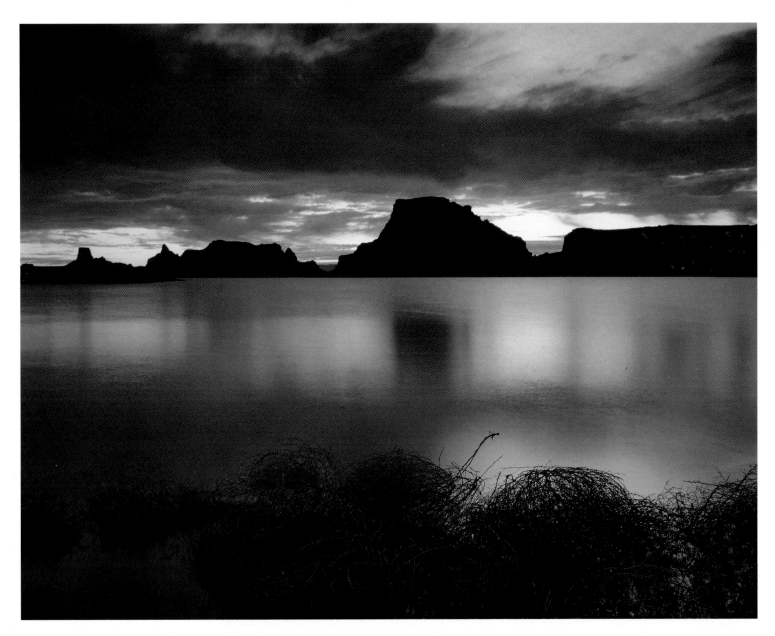

GREGORY BUTTE, LAST CHANCE BAY, NOVEMBER
Late fall light spills from heaven to earth. Weary tumbleweeds,
blown for miles across open desert, rest along lake shores.

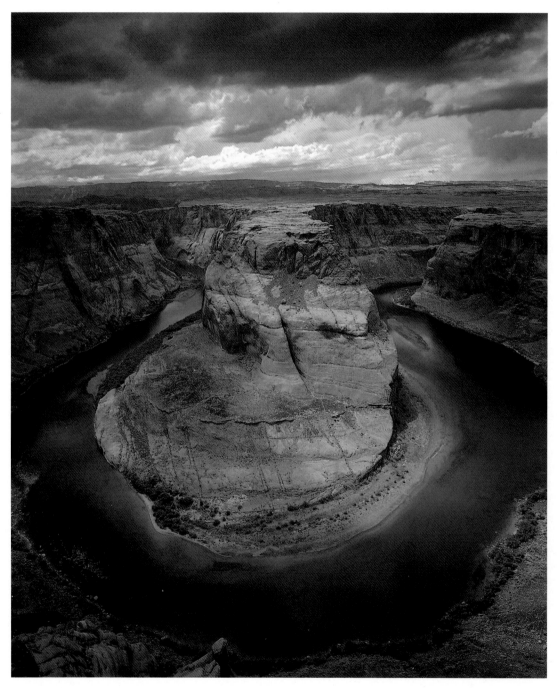

BELOW GLEN CANYON DAM, MAY
This river bend dramatically shows the course and depth of the original Colorado River gorge. Waters once flowed warm, muddy red; they now gush from Lake Powell cold and emerald, creating a very different riparian habitat in the Grand Canyon. Gary Ladd calls this viewpoint "Tad Nichols Overlook" in honor of the modest photographer from Tucson who floated, wandered, explored, and exulted in Glen Canyon before the lake began to rise. His photographs and cinematography are priceless.

Opposite:
ESCALANTE CANYON, JANUARY
A plume of silt from the Escalante River, a major Glen Canyon tributary, spurts into the winter lake waters.

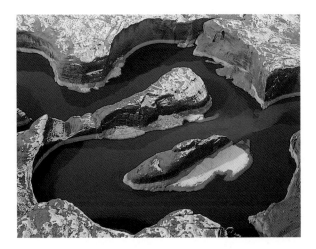

Challenges

The Colorado River has confounded humans for thousands of years.
Sheer sandstone walls plummet down to the river's edge from relatively flat
tablelands above—not just in one place, but along hundreds of miles of
the canyons we now call Cataract, Glen, Marble, and Grand. Sandwiched
between those great red walls flows a relentless current of water, intent on
carrying each winter's snowmelt down from the mountains and out to the
Sea of Cortez. The river hasn't stopped people from roaming through this
area, but it certainly has slowed them down.

In geologic terms these almost impassable gorges are relatively young.
Sediments from ocean floors and lake beds, as well as sand dunes blown in
from the Ancestral Rockies, stabilized, solidified, and cemented together over
millions of years forming uniform masses of rock. Tectonic plates slid and
crunched; land heaved and often cracked; and this region began to lift up. Ten
million years ago a huge slab of this land—the 130,000-square mile Colorado
Plateau— pushed skyward, raising the horizontal layers of sedimentary rock
on a northward tilt over a mile above surrounding provinces.

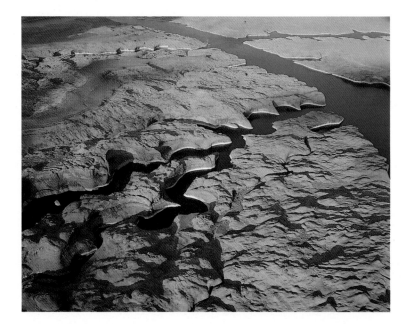

Rivers and streams cut ferociously through this slanted plateau, carrying away more than six inches of rock every thousand years. Water has flushed about 5,000 feet of sedimentary sandstone out to sea, much of it via the Colorado River. Such intense slicing and sluicing away has created vertical cliffs along the river's bed. Great spring runoffs—carrying melted mountain snows and blocks of ice, dead trees and loosened boulders—swept through Glen Canyon every year completely flooding its bottom, gouging into soft underbellies of sandstone walls. Even after raging spring waters passed, thunderstorms anywhere upstream would send down flash floods, frothing torrents of water and debris.

People never lived in Glen Canyon with any permanence: they watched the floods, and chose to live above the river. Nomadic bands wandered through here for more than 7,000 years, following the seasons and the paths of migrating animals. Spring comes early and autumn lingers on in desert canyons; they made good places to resupply stashes of food and medicines, to heal from (or get ready for) bitter winters.

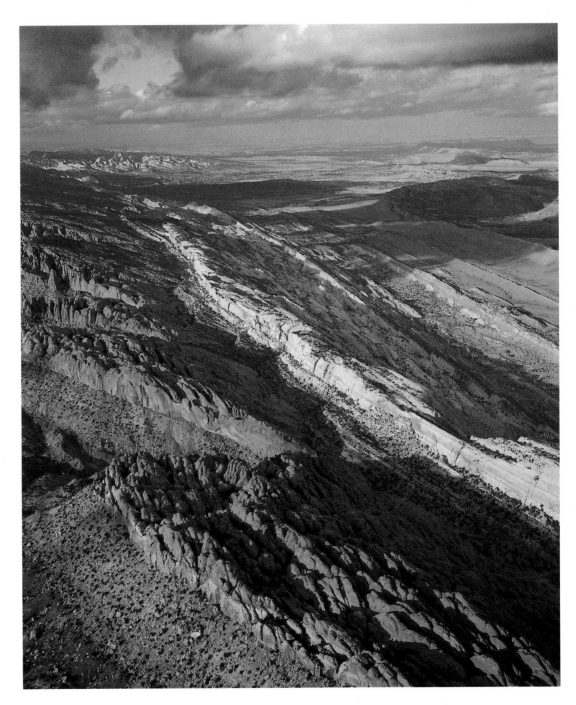

WATERPOCKET FOLD, DECEMBER
The southern end of the hundred-mile long Waterpocket Fold extends beyond the boundary of Capitol Reef National Park into Glen Canyon National Recreation Area in the vicinity of Iceberg Canyon to Annies Canyon. This aerial view just north of the National Recreation Area's boundary reveals the zone of steeply-dipping rock strata warped about sixty-five million years ago as the Colorado Plateau uplifted. The Rocky Mountains formed during the same period.

Opposite:
FORGOTTEN CANYON, AUGUST
Ninety-six major side canyons twist into the main channel of Lake Powell, each with its own idiosyncrasies, virtues, and secrets.

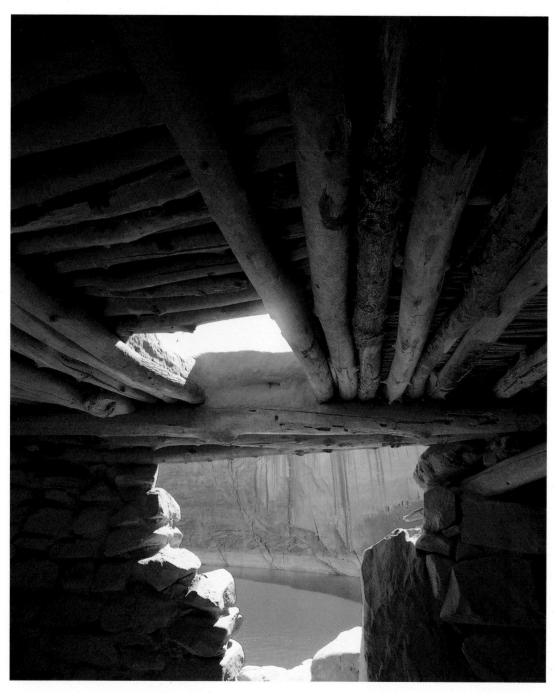

THREE ROOF RUIN,
ESCALANTE CANYON, SEPTEMBER
Anasazi *("Ancient People") built
hundreds of homes and storage rooms
above Glen Canyon's floor. Some
communities perched along the canyon
rims. This reconstructed ruin shows
rockwork and log roof cribbing typical
of their dwellings.*

By A.D. 500 a people we call *Anasazi* were nursing fledgling corn fields in quiet, rich-soiled side canyon bottoms. The "Ancient People" lived with the earth and her seasons, apparently using Glen Canyon as a bountiful garden while living above on high rocky rims, or in small homes suspended between earth and sky along a cliff's ledge.

These small communities had some contact with the outside world. Travellers often came through, picking their way down treacherous vertical pitches while carrying precious cargo on their backs—perhaps cotton seed, or turquoise, or flint. Did traders also bring stories of raiding war parties? Did they introduce disease? Did they speak of finer lands to the south? We don't know; but something caused the Anasazi to abandon their homes and fields in Glen Canyon. Everyone had left by A.D. 1300.

Other native peoples roved through these canyons for the next six hundred years, well into the twentieth century, but none settled here permanently. Utes and Southern Paiutes foraged the northern and southern ends of the canyon; later, Navajos moved in and began absorbing lands east of the Colorado, south of the San Juan River. Native peoples knew the magic places—the seep springs, the soaring natural bridges, the river crossings: invaluable desert secrets, as generations of explorers after them would attest.

Europeans and Euro-Americans, more often than not, cursed and fought with the convolutions of this rocky land as they sought to pass through it, burdened with both possessions and eastern sensibilities. Traversing the Colorado's steep gorge with a single trader's pack is challenging, but the sheer canyon walls do offer sparse hand and toe holds which help a human climb in and out. For the Spanish friars Dominguez and Escalante, travelling with horses in 1776, or for Mormon pioneers carrying all their possessions by oxen and cart in 1879, canyon sides rose like the walls of Jericho. In fact, more than three centuries of missionaries, traders, settlers, explorers, trappers, miners, railroad tycoons, and sightseers have searched for river crossings; they've only found six in the 550 miles of Colorado canyon between Moab, Utah, and the Arizona/Nevada border.

For one man, crossing the river was not enough. John Wesley Powell wanted to explore the whole length of the Colorado, an area which, in 1869, all maps still showed as an "unexplored" blank. He wanted to map it, to study its geology, to understand it. For months Powell and his men plunged down a river previously assumed impassable.

Glen Canyon offered a welcome oasis of calm waters and serene beauty between the terrifying days in Cataract Canyon and unknown horrors further downstream. According to Powell's published account, *Canyons of the Colorado*, he and his crew spent a week

> *gliding past these towering monuments, past these mounded billows of orange sandstone, past these oak-set glens, past these fern-decked alcoves, past these mural curves . . . stopping now and then, as our attention was arrested by some new wonder.*

Powell stood among those explorers and scientists who came closest to knowing all this country, or at least, to discerning its true potential and limitations. A visionary, he did not propose massive dam or irrigation projects for this region. A pragmatist, he understood the limitations of water resources west of the hundredth meridian. At an irrigation convention in 1893, Powell stated,

> *There is not enough water to irrigate all these [Western] lands; there is not sufficient water to irrigate all the lands which could be irrigated. . . . I tell you, gentlemen, you are piling up a heritage of conflict. . . .*

The gathered crowd booed him, and ignored his advice. Over the next century the monied interests won, as they most often do; those men who believed that water should be controlled for the good of humankind—to irrigate, to prevent flooding, to generate power—prevailed. The impoundment of the Colorado River began in 1931 with the construction of Boulder (Hoover) Dam. Other dams were slated for further up the Colorado; although conservationists swayed Congress from building one in Dinosaur National Monument, construction on Glen Canyon Dam began in 1956. Seven years

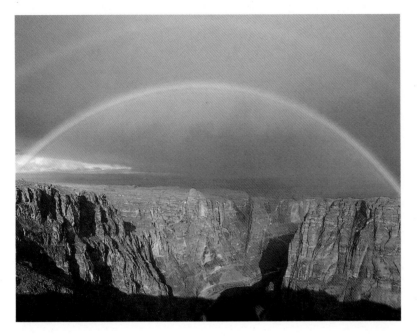

BELOW GLEN CANYON DAM,
FEBRUARY
A double rainbow bridges the deep gorge carved by the Colorado River. John Wesley Powell noted in his journal, after floating through relatively low-walled, broad Glen Canyon, "Today the walls grow higher and the canyon much narrower . . . [changing to] limestones and hard sandstones [which] bode toil and danger."

later, the gates closed and waters began filling the canyon. Glen Canyon's Colorado no longer inspires dread with spring floods or confounds travellers with impossible crossings. Humans have, at least momentarily, mastered the river's challenge.

Powell's "heritage of conflict" has taken on new depth and bitterness as economists, engineers, and environmentalists debate the costs of flooding desert canyons. Western author Wallace Stegner poignantly summed up this controversy, writing that "In gaining the lovely and the usable, we have given up the incomparable."

Glen Canyon's Lake Powell now challenges a new generation of humans with a vital task: the integrated, consistent, wise care of both lovely, usable Lake Powell and its incomparable surroundings. Conservationists and congressional leaders, park managers and visitors, houseboaters and hikers alike all hold responsibility for protecting these ochre rocks and azure waters for the creatures who still call Glen Canyon home.

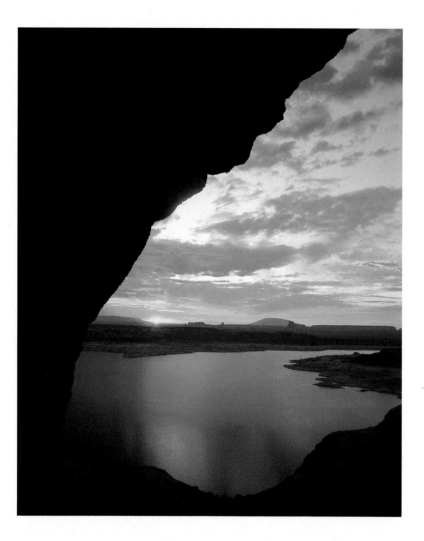

A wild blue heron, equally at ease on waters still or flowing, skims along Lake Powell's surface, her wings weaving crescents of shadow upon high rock walls as she lifts off the reservoir. Her silhouette climbs up past the bleached, horizontal high water marks and reflects darkly on the burnished stone sculptures of Glen Canyon's gorge. The heron looks down, searching for schools of fish playing below her, and then looks up again, over orange rock walls, past lavender plateaus and on to the distant mountains.

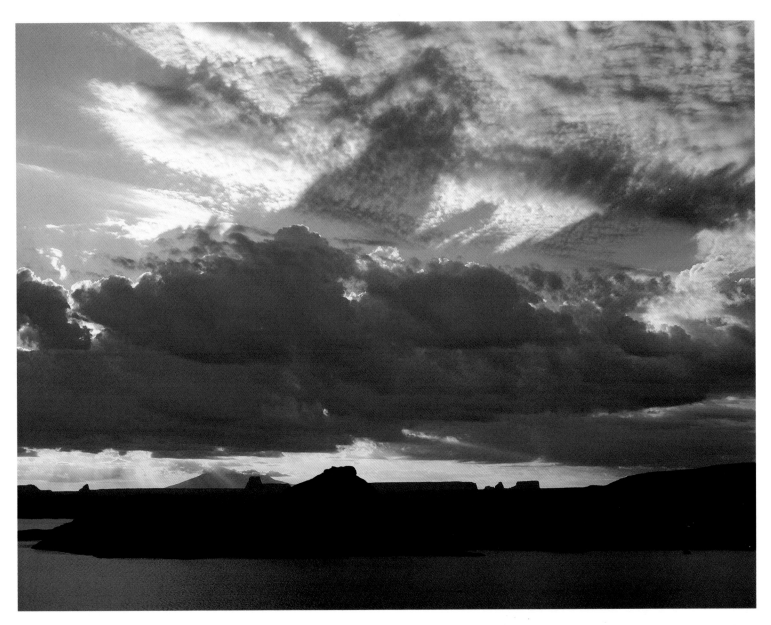

LAKE POWELL, JULY
Opposite, a summer sun rises between flat Kaiparowits Plateau and rounded Navajo Mountain, with Lake Powell brimming between them.

LAKE SHORE DRIVE, PAGE, ARIZONA, JULY
Morning cloud shadows projected on a screen of thin clouds hang above Tower Butte, above.

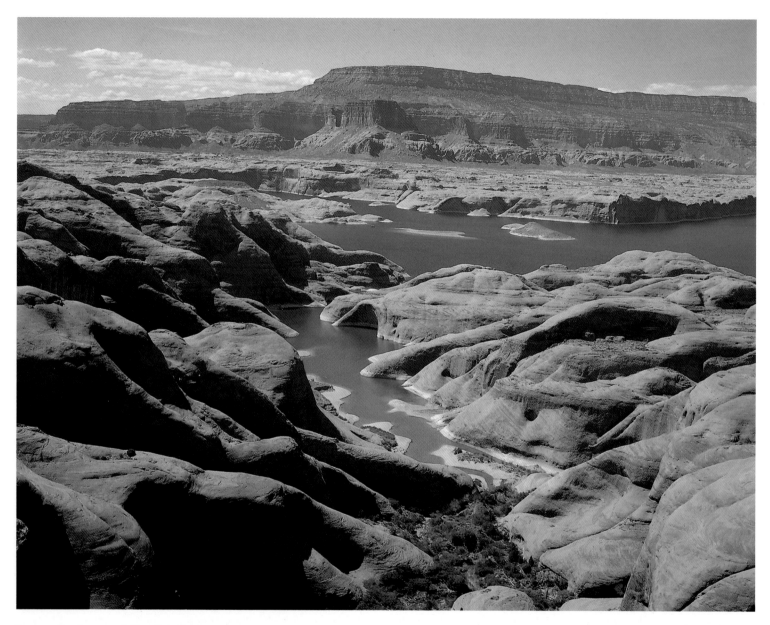

SECRET CANYON, OFF OAK BAY, MAY
Navajo sandstone undulates down to the merging green and blue of canyon and lake waters. Kaiparowits Plateau dominates the skyline. Boaters, once subject to river currents, now travel at will up or down Glen Canyon.

GLEN CANYON AREA, AUGUST (OPPOSITE)
Beautiful, highly toxic sacred datura (Jimson Weed), blooms only at night, closing again each morning. Native Americans use sacred datura in specific religious rituals.

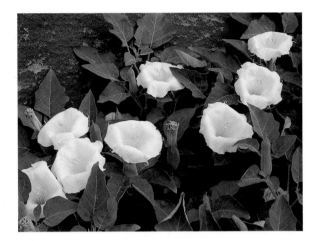

*The Colorado Plateau selects its people.
If chosen you know: this landscape
speaks to your emotions and spirit.
You belong.*

STEPHEN TRIMBLE,
BLESSED BY LIGHT, 1986

GIFTS

I say the word "desert" to most people and they stare at me blankly, wondering what draws me to a solidified ocean of red rock and sand, a place they view as a scorching, barren oven without mercy or life. When I explain that a lake pools in the middle of all that heat and stone, they better understand—at least there's something to *do*.

Most people who spend time on Lake Powell come for the cool, silken pleasures of limitless water, a wonderland for houseboaters, motorboaters, waterskiers, jetskiers, parasailors, boardsailors, sailboaters, and fishermen. Visitors gape at sculpted rock backdrops and motor miles to search out well-known stone marvels—natural arches or human-made ruins. Few venture off their boats to wander into the blazing desert.

But one day, seeking shade or wishing to stretch their legs in the cooler evening air, a small group leaves its boat to wander up a quiet side canyon or climb a shoulder of curvaceous rock to see what this desert offers. A few of these explorers will fall in love with the starkness, the simplicity, the absolute subtlety of desert rhythms. They will realize that Lake Powell is just the

beginning, just the opening stanza of a spectacular wilderness chorus. Glen Canyon Dam, by converting the waters of the Colorado River into a simple and navigable lake, has posed a difficult paradox: access. As one longtime desert wanderer said, "My friend loves the dam because it allows more people easy access into more canyons. I hate it for the same reason."

This paradox tears at me. I hope Gary Ladd's photographs will entice travellers to explore beyond the lake—but I worry for the delicate landscapes hikers will tramp across on their dryland journeys.

I fear the uncaring footstep that crushes delicate cryptobiotic crusts, the careless contamination of precious water, the thoughtless picking of a pretty flower. Desert communities live so sparely that every single plant creates food or shelter for small creatures. Silt-laden water holes succor thirsty animals. Fingers of Lake Powell stretch across only thirteen percent of vast, still largely pristine Glen Canyon National Recreation Area. Much of the land remains untouched, a sanctuary we humans can easily disrupt.

But for all my concern, I believe only people who experience desert beauty firsthand will ever choose to learn these canyons' ways, to love and protect these intricate networks of rock and precious, hidden life. Only those who expose themselves to the magic of desert light will receive the enchantress' gift: her wand will touch them deep inside, warm and sooth their minds, refresh and rejuvenate their very souls.

—Anne Markward

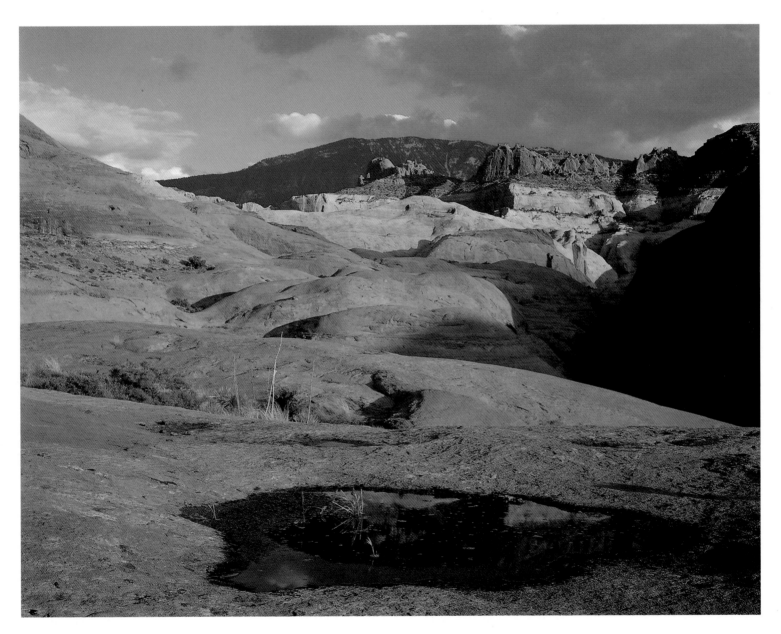

GLEN CANYON AREA, APRIL
*Rainwater pooled in sandstone potholes may host tadpoles
and thirsty creatures—even hikers—before evaporating.*

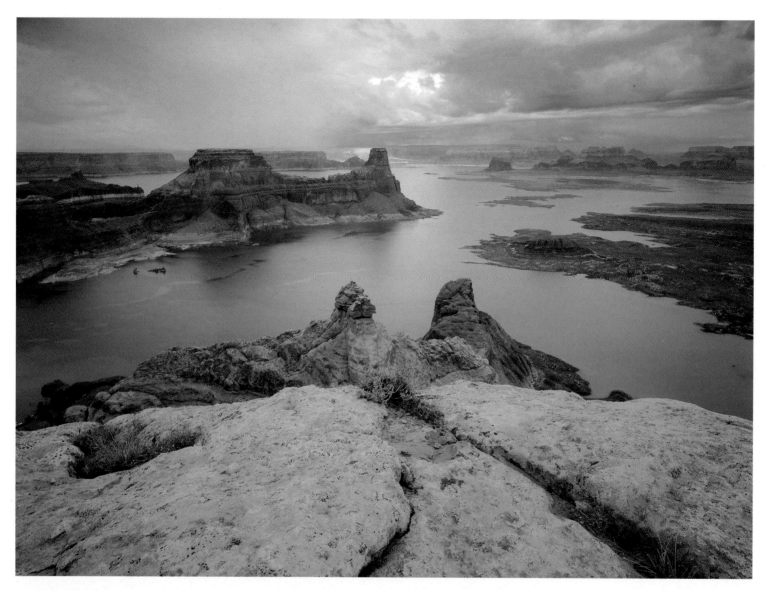

PADRE BAY, MAY
*Padre Bay is named for two Spanish friars, Francisco Atanasio Dominguez
and Silvestre Velez de Escalante, who with a party of explorers forded the
Colorado River here in 1776.*

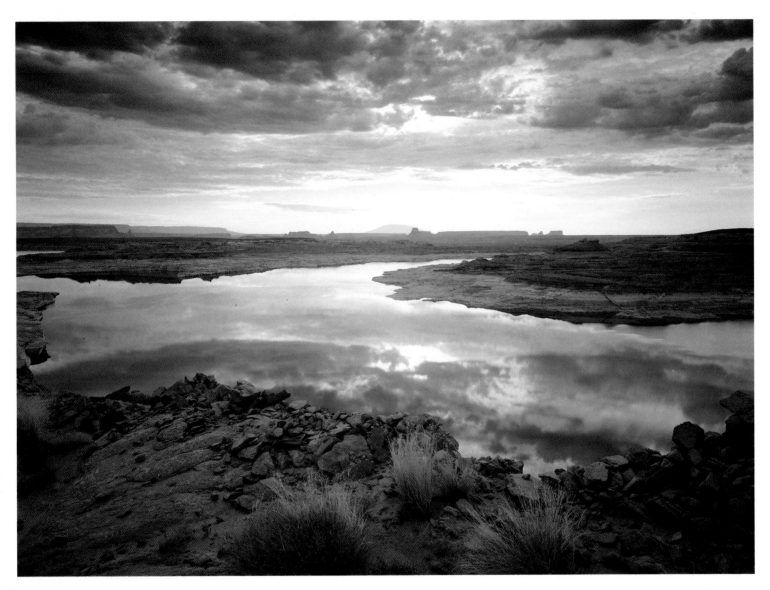

LAKE POWELL, AUGUST
Morning along Lake Shore Drive near Page, Arizona.

GLEN CANYON AREA, JANUARY
Frost rapidly evaporates as morning sun warms air and rippled sand.

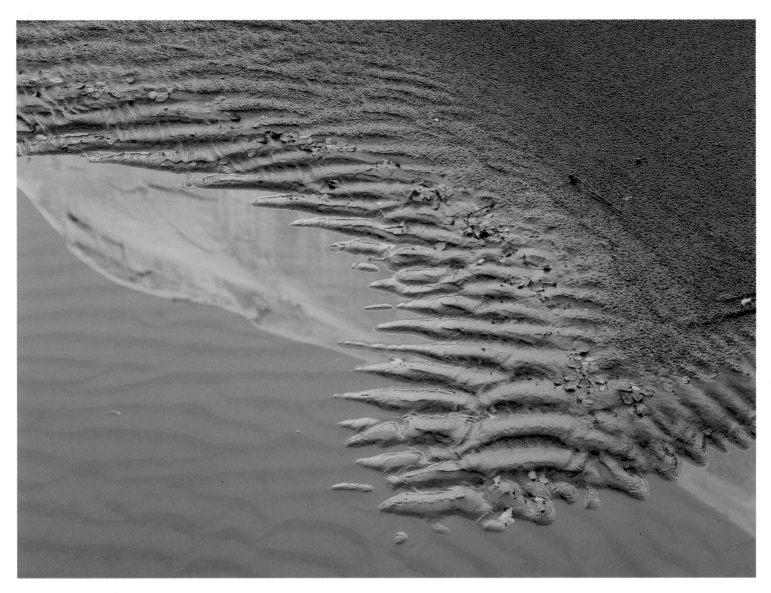

GLEN CANYON AREA, OCTOBER
Early sun glinting off a high cliff reflects in a still pool edged with ripple marks.

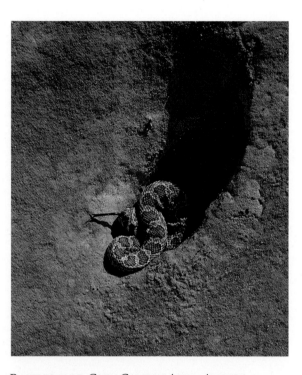

RATTLESNAKE, GLEN CANYON AREA, AUGUST
*A small rattlesnake hides in a rock niche, trying
to avoid intruders. Rattlesnakes "hear" by sensing
vibrations; they "smell" by extending their tongues.*

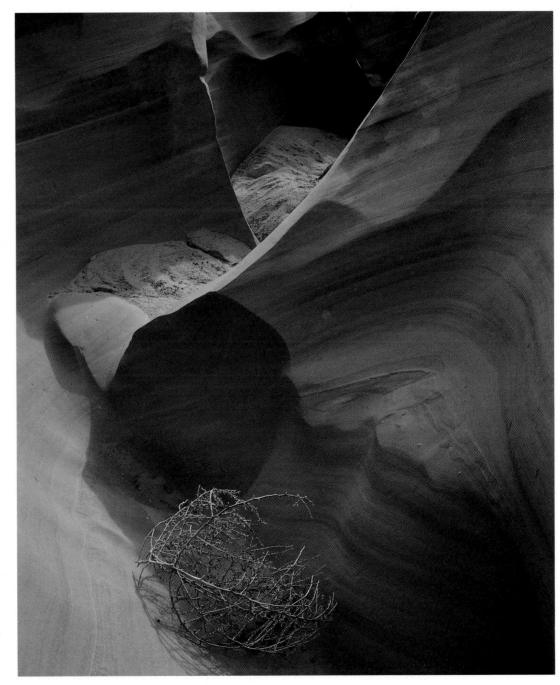

SNAKE CANYON, NOVEMBER
Spring winds can drive herds of tumbleweeds into narrow canyons, making them all but impenetrable to hikers until floods flush them away to the lowlands.

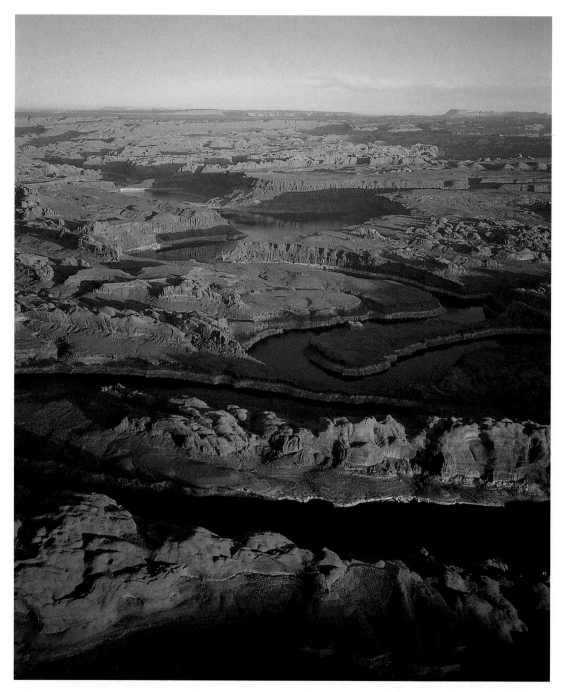

SAN JUAN RIVER ARM,
AERIAL, NOVEMBER
*Lazy loops of the San Juan River,
a major southwestern artery, carry
snowmelt from the Rocky Mountains
to the Colorado River.*

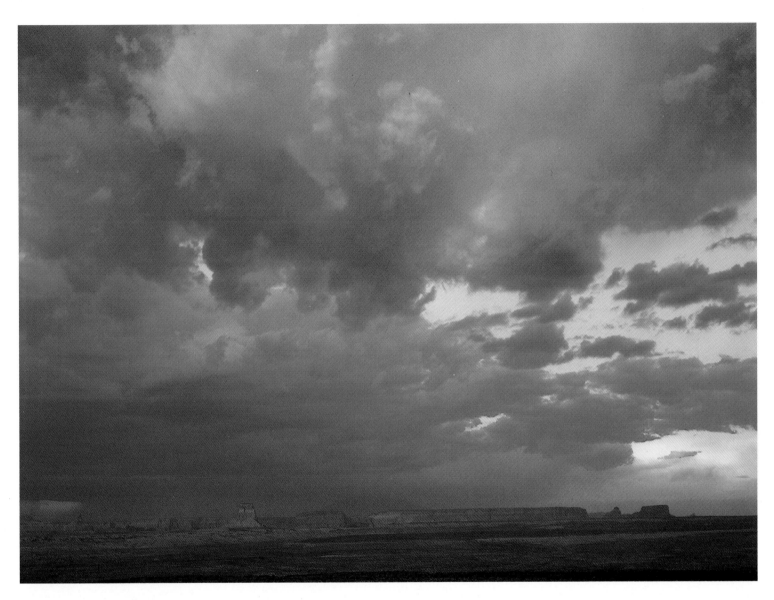

VIEW FROM PAGE, SEPTEMBER
"Rain here is not a casual atmospheric condition; it is a gift of the gods. . . .
Men here for centuries have danced for rain in prayers of moving rhythm."
–*Frank Waters,* The Colorado

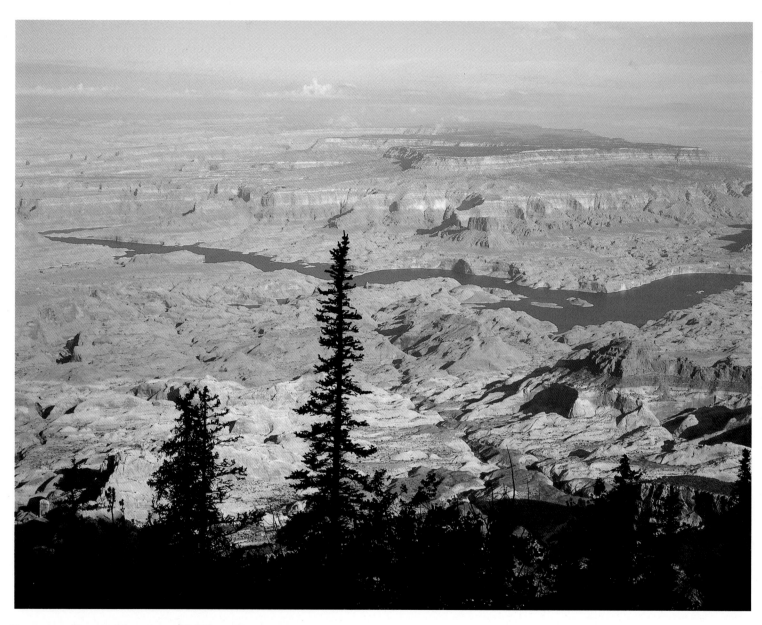

VIEW FROM NAVAJO MOUNTAIN, 10,388 FT, SEPTEMBER
Lake waters snake through a rugged landscape. Navajo Mountain's maze of rock dwarfs 290-foot high Rainbow Bridge (far left, center). The Kaiparowits Plateau (upper center) rises nearly 4,000 feet above the lake.

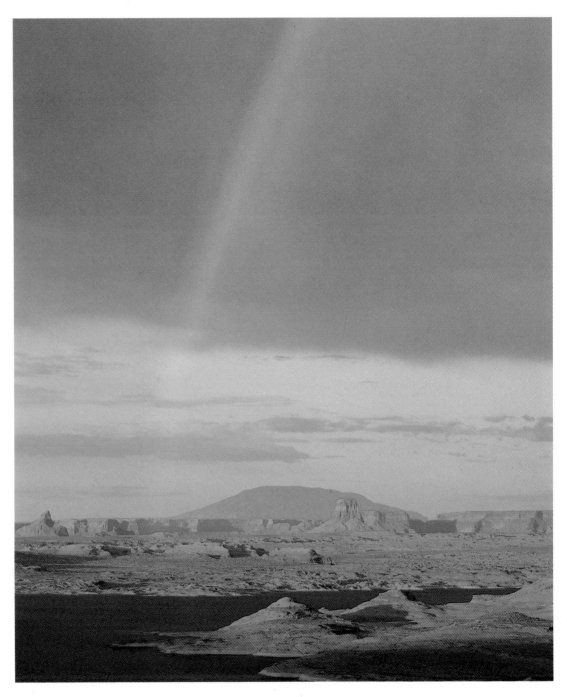

VIEW FROM LAKE SHORE
DRIVE, PAGE, JUNE
*Navajo Mountain lies at
a rainbow's end. The* Dineh
*(Navajo people) believe the
mountain to be sacred.*

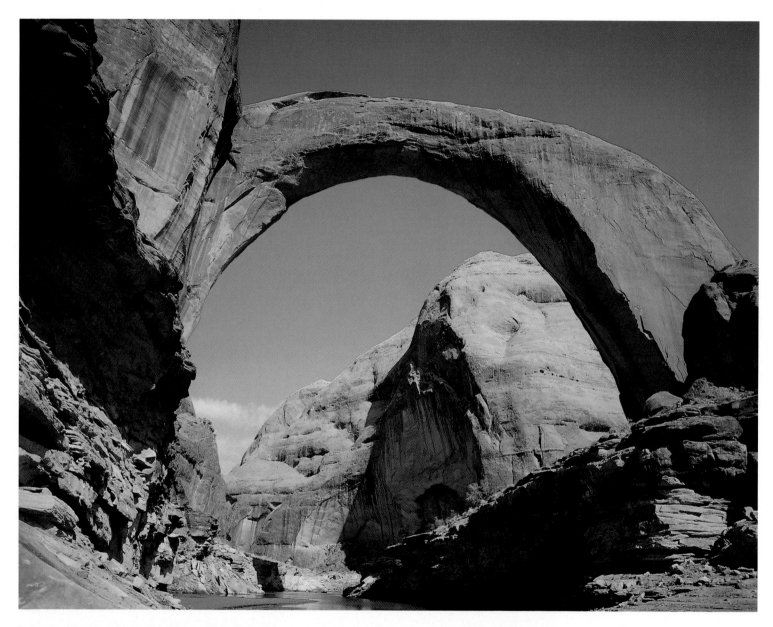

RAINBOW BRIDGE NATIONAL MONUMENT, MARCH
Rainbow Bridge arches to a height of 290 feet, and spans 275 feet.

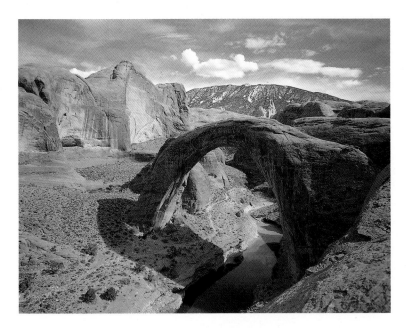

RAINBOW BRIDGE AND NAVAJO MOUNTAIN, MARCH

*Rainbow Bridge, made of Navajo Sandstone, arches
across a streambed cut into Kayenta Sandstone. Bridge
Creek once meandered back and forth, sometimes abandoning
old channels in favor of new ones, often leaving fins or domes
of Navajo Sandstone isolated between meanders. Perhaps one
day, probably thousands of years ago during a flood, Bridge
Creek punched a shortcut through an overhanging fin. Most
likely the initial hole through the fin was at or near the
Navajo-Kayenta contact. Then, while the stream patiently
cut downward through the more resistant Kayenta, the hole
in the Navajo enlarged as slabs of rock fell from the under-
side of the breached fin. Slowly, sporadically, eventually,
a "rainbow" of rock took shape.*

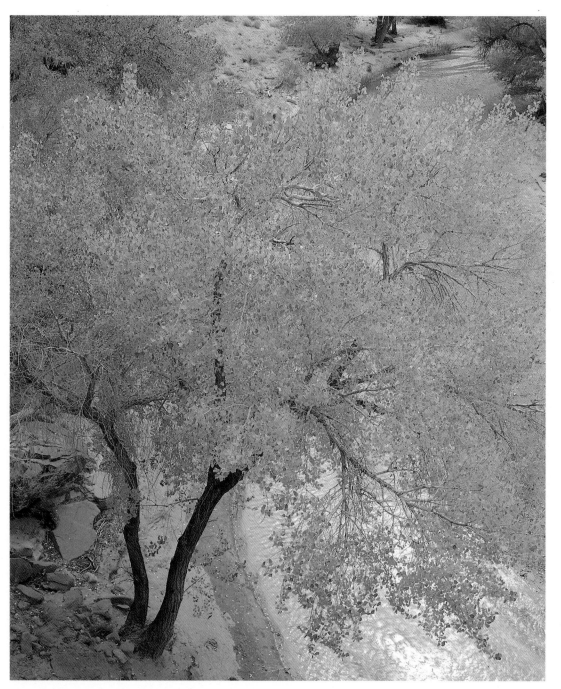

CHAOL CANYON, OCTOBER
In autumn, perennial Kaibito Creek trickles along for miles decorated by colorful cottonwoods. Cottonwoods need reliable moisture; their presence always indicates a good water source.

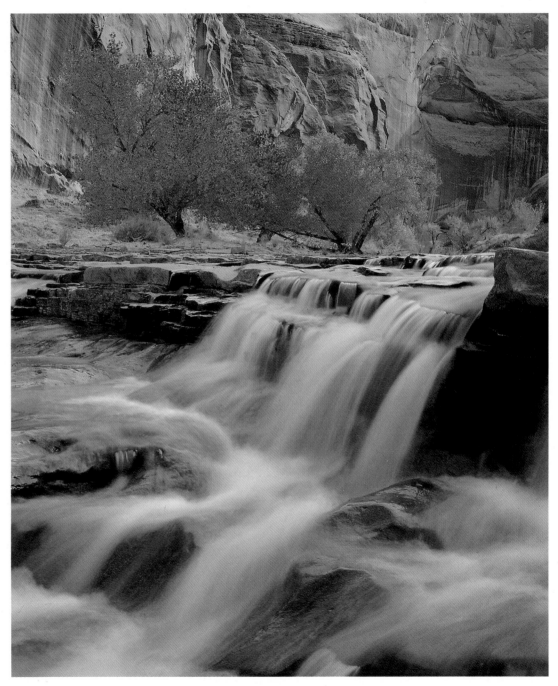

CHAOL FALLS, NOVEMBER
Kaibito Creek cascades through Chaol Canyon about two miles above the confluence with Navajo Canyon. When Lake Powell is at full pool it submerges the lower half of Chaol Falls.

BELOW GLEN CANYON DAM, APRIL
A redbud tree blossoms in early spring along the Colorado River.

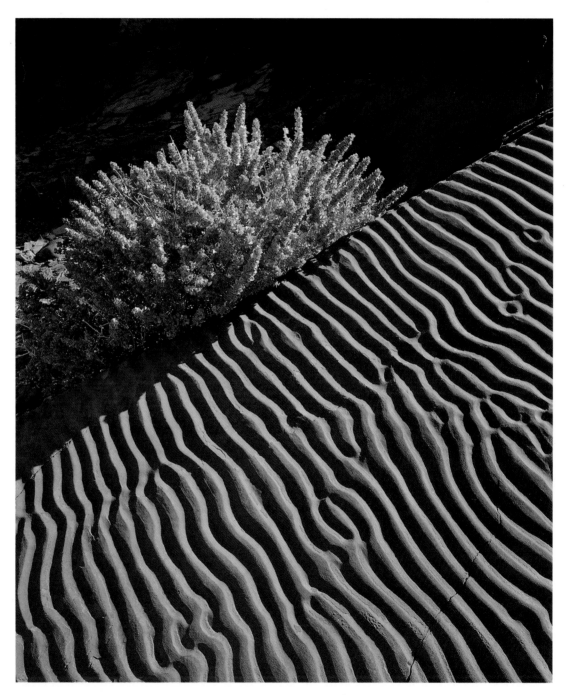

FARLEY CANYON, SEPTEMBER
Tenacious saltbrush grows next to a slab of ripple rock from the Moenkopi Formation, a record of streams and tidal mudflats that existed here about 235 million years ago.

49

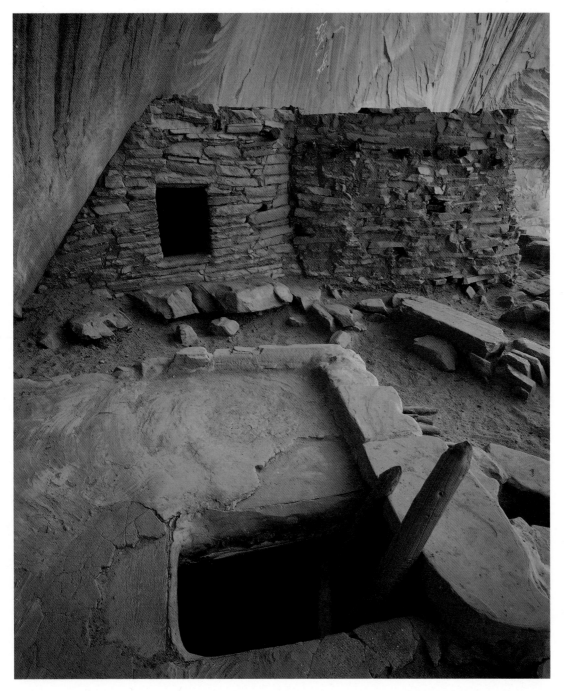

DEFIANCE HOUSE RUIN,
FORGOTTEN CANYON, SEPTEMBER
*Restored by the National Park
Service, Defiance House is named
for the unique rock art decorating
its alcove wall. Archaeological studies
reveal that the Anasazi occupied
Defiance House for about 200 years,
from 1100 to 1300 A. D. A ladder
protrudes from the* kiva, *an under-
ground ceremonial chamber probably
used for both religious and social
occasions.*

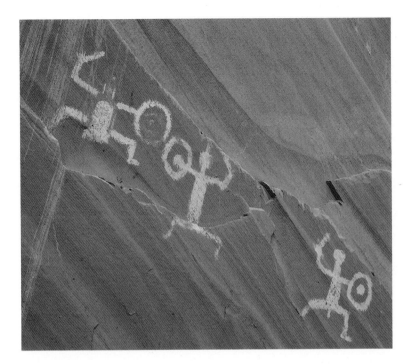

PICTOGRAPHS AT DEFIANCE HOUSE RUIN
FORGOTTEN CANYON, SEPTEMBER
The combative stance of these three warriors
is quite unusual, challenging the usual
assumption that the Anasazi were a peaceful
people. Two warriors hold their weapons in
their right hands, while the third figure is left-
handed. Each figure is nearly four feet high.

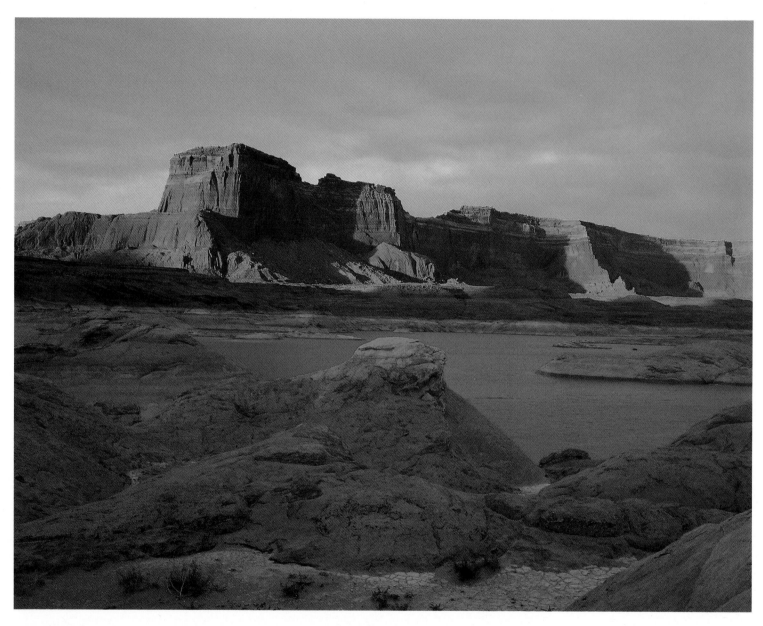

FACE CANYON, JUNE
"The colors are such as no pigments can portray. They are deep, rich, and variegated, and so luminous are they, that light seems to glow or shine out of the rock rather than to be reflected from it." — *Clarence Dutton,* Geology of the High Plateaus of Utah, *1880*

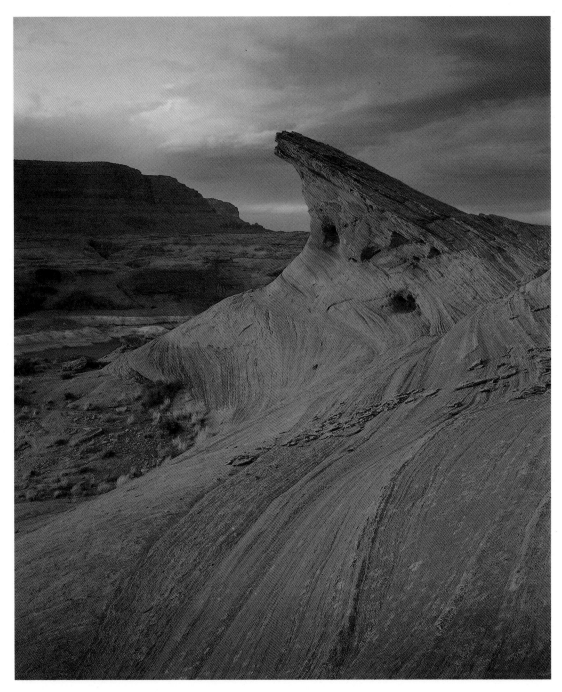

NEAR MUSIC TEMPLE CANYON,
NOVEMBER
*200 million-year-old Navajo
Sandstone is the legacy of a once-
extensive sandy desert resembling
today's Sahara. Crossbed patterns
reveal ancient shifting wind directions
as the dunes moved and reshaped.
Here a portion of the down-wind slope
of an old dune has been isolated by
recent weathering and erosion.*

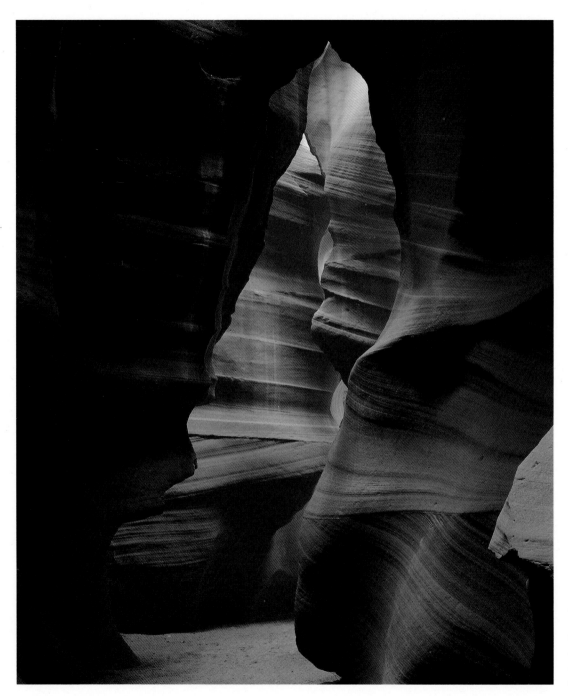

ANTELOPE CANYON, APRIL
"The finest workers in stone are not copper or steel tools, but the gentle touches of air and water working at their leisure with a liberal allowance of time." – Henry David Thoreau

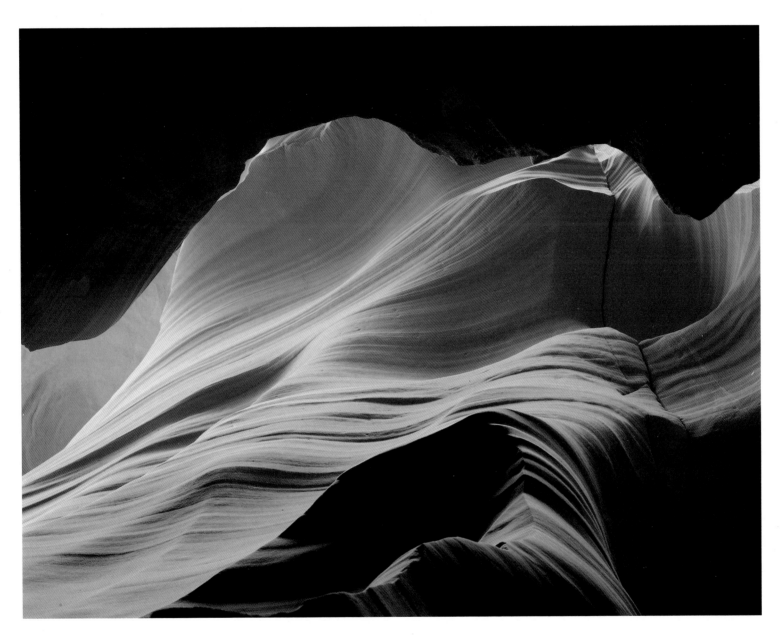

NAMELESS SLOT CANYON, MAY
Curtains of salmon-colored rock imbue this quiet slot with rosy incandescence.

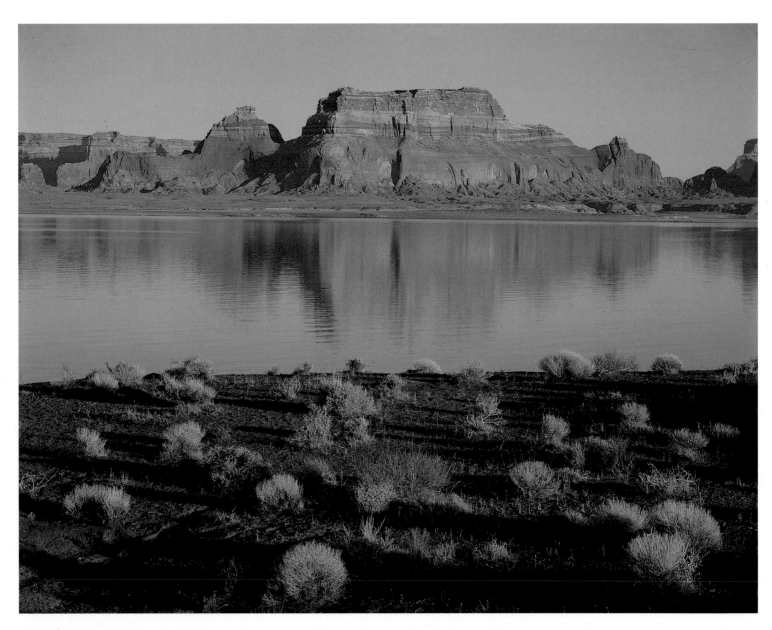

PADRE BAY, FEBRUARY
Breezes and boat wakes are scarce in February, when
sandstone buttes and mesas reflect in still lake waters.

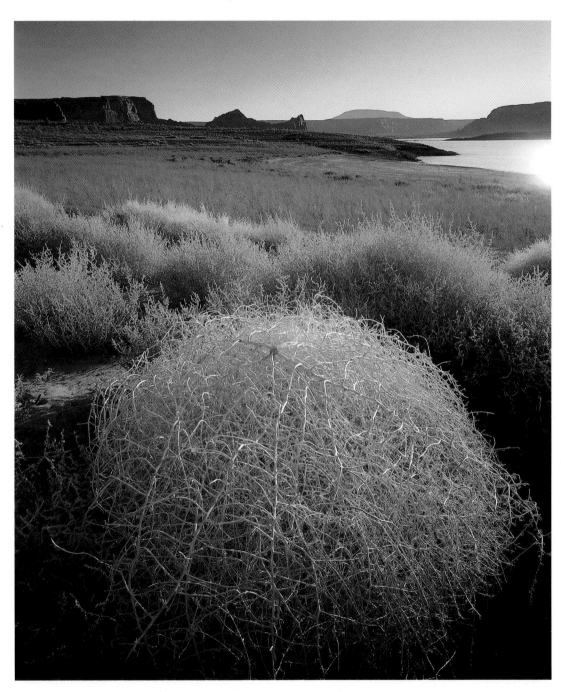

PADRE BAY, NOVEMBER
Although these bristly, rolling plants have become popular icons of the Southwest, tumbleweeds don't belong here. Inadvertently imported in the 1800s from the far side of the planet, the tumbleweed is also known as Russian thistle.

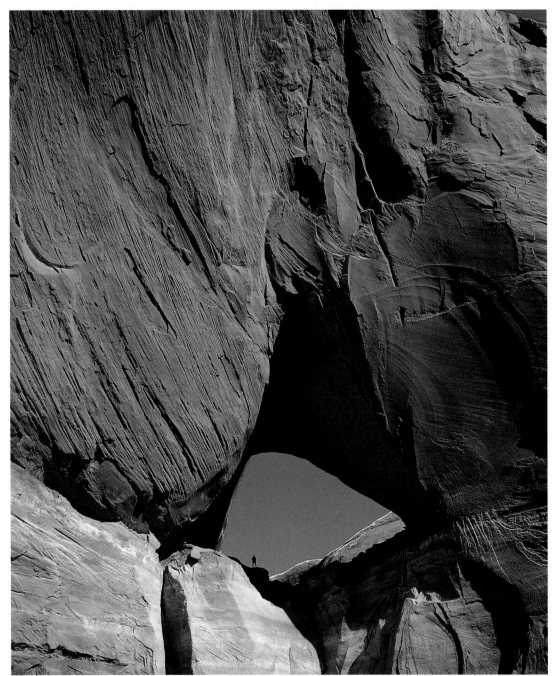

LA GORCE ARCH,
DAVIS GULCH, JANUARY
A hiker stands dwarfed by a natural window in sandstone. Winter can be an ideal time to hike the canyons around Lake Powell—pleasant temperatures and few other visitors.

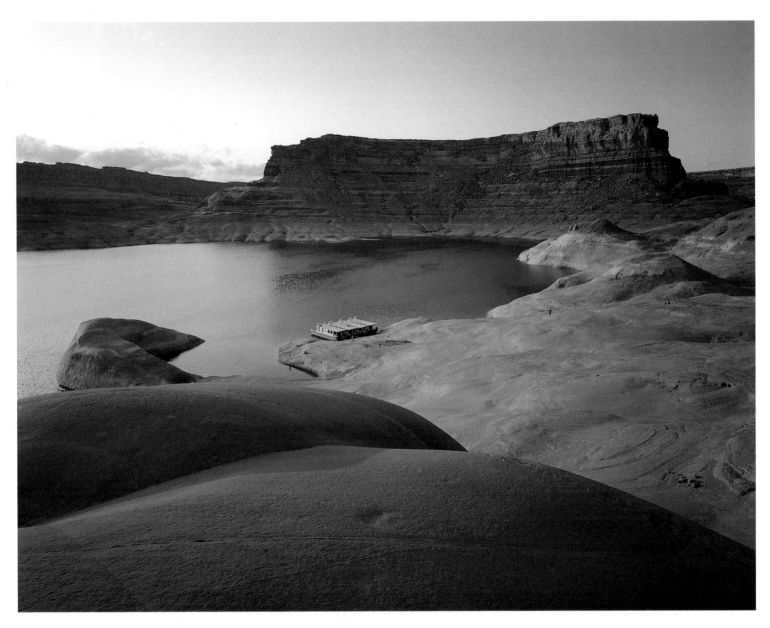

PADRE BAY, NOVEMBER
*Four houseboats beach in a peaceful inlet as aspiring photographers
fan out across the undulating slickrock to enjoy the low-angle light
of a late fall afternoon.*

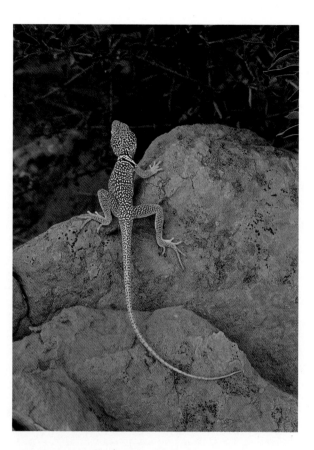

Collared Lizard, June
Momentarily at rest on a sandstone ledge, this quick, bright green denizen of Glen Canyon sports a distinctive collar of two black bands around one of white.

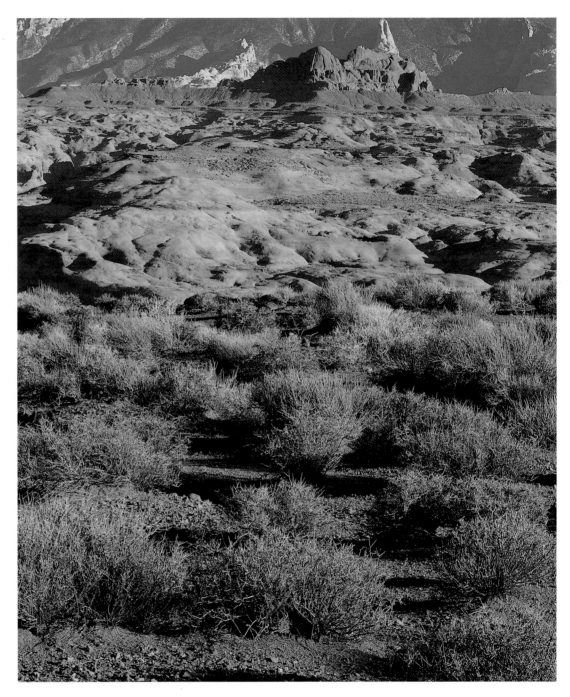

GLEN CANYON AREA, NOVEMBER
Hardy blackbrush, a member of the rose family, often grows on sandy benches such as this one near Navajo Mountain.

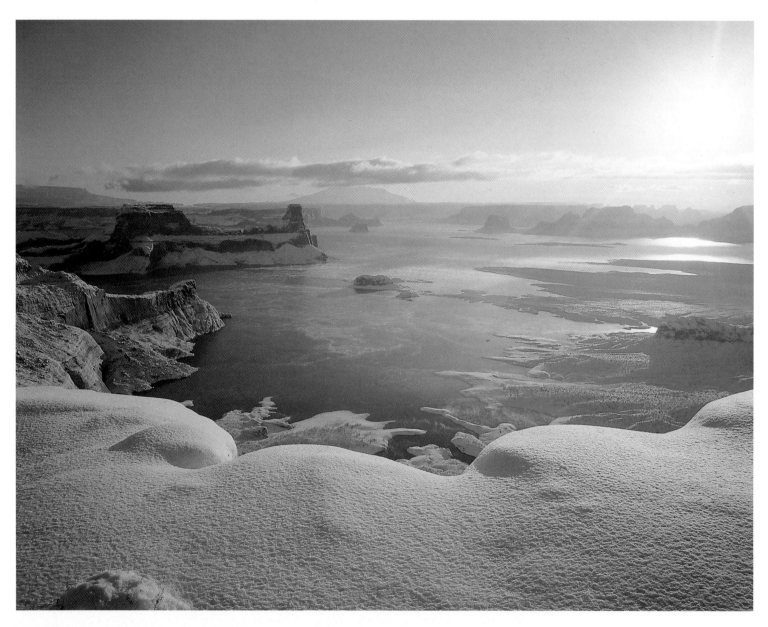

PADRE BAY, JANUARY
The night's snow may quickly melt, but first light reveals a shimmering world of blue and white.

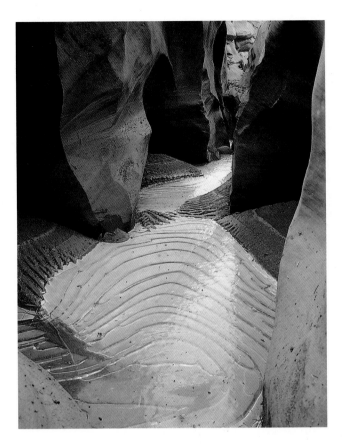

Navajo Canyon tributary, January
Ice-clad pools crack and splinter, and deep narrow canyons hold their chill without direct sun to thaw them. The winter Lake Powell, when ice, fog, snow, and cold come, is a world unknown to most visitors.

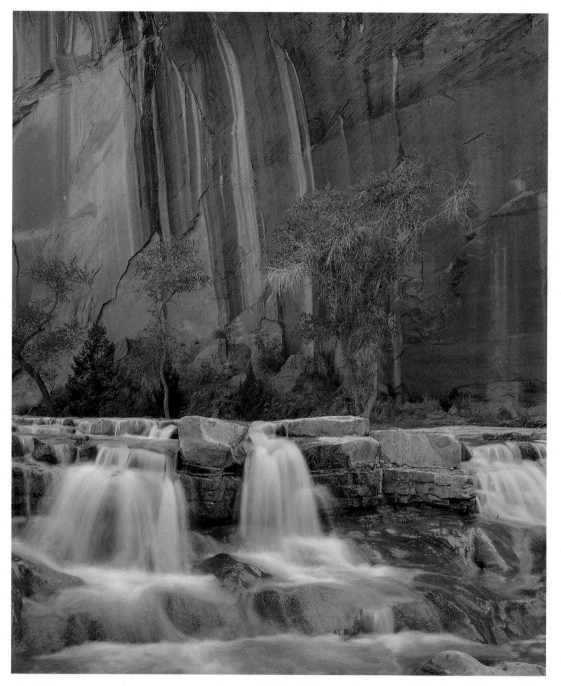

CHAOL CANYON, SEPTEMBER
Kaibito Creek cascades over a ledge of limey Navajo Sandstone. These thin beds of slightly more resistant rock are believed to be the product of fresh water oases nestled between the sand dunes of the Navajo desert. Fossil tracks indicate that dinosaurs wandered through the waterholes.

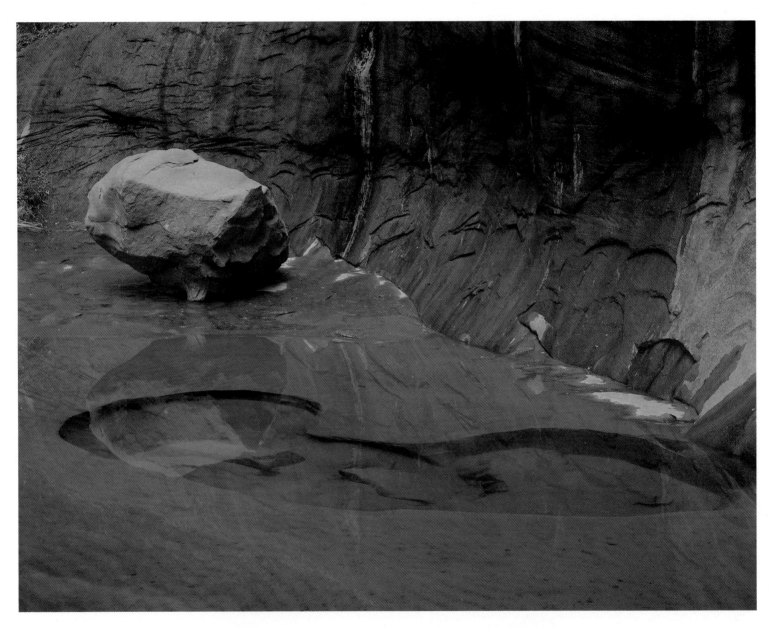

ESCALANTE CANYON TRIBUTARY, FEBRUARY
On stormy days a plume of flood water shoots from a hanging pouroff, falls, and collides with the canyon floor below. The water, laden with sand and gravel, routs a sharp-edged pocket into the stream bed. As the flow varies, the impact site wanders slightly, producing a free-form-shaped plunge pool. It is likely that the boulder also arrived via the waterfall.

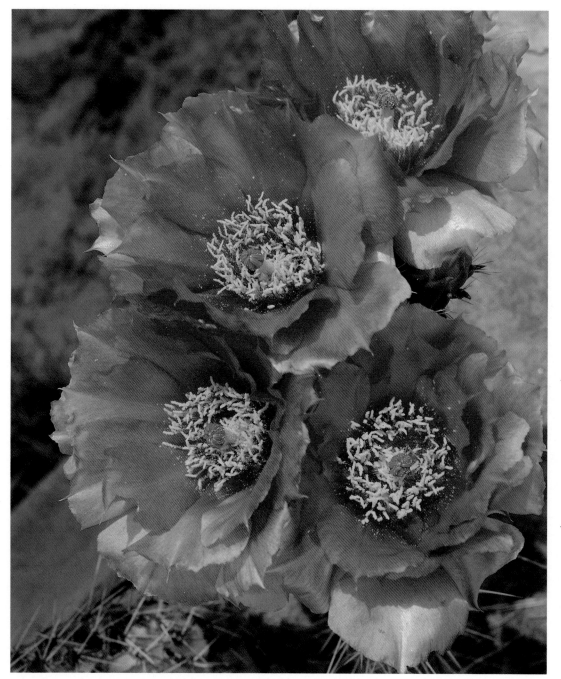

"... the strangeness and wonder of existence are emphasized here, in the desert, by the comparative sparsity of flora and fauna; life is not crowded upon life as in other places but scattered abroad in spareness and simplicity, with a generous gift of space for each herb and bush and tree, each stem of grass, so that the living organism stands out bold and brave and vivid against the lifeless sand and barren rock. The extreme clarity of desert light is equaled by the extreme individuation of desert life forms. Love flowers best in openness and freedom."
–Edward Abbey, Desert Solitaire, 1968

DESERT FLOWERS
OF THE GLEN CANYON AREA

Left:
PRICKLY PEAR

Opposite, clockwise from top right:
SPIDERWORT; PHACELIA;
GLOBE MALLOW; CLARET CUP

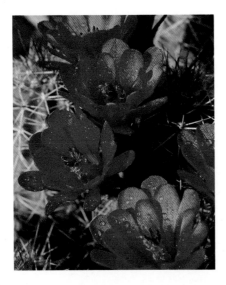

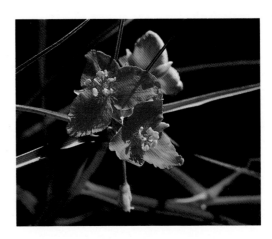

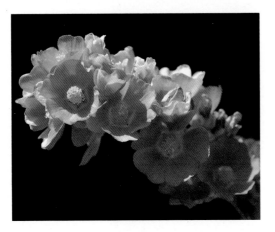

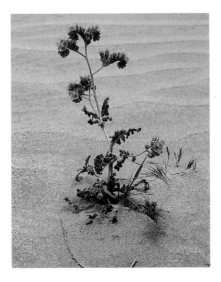

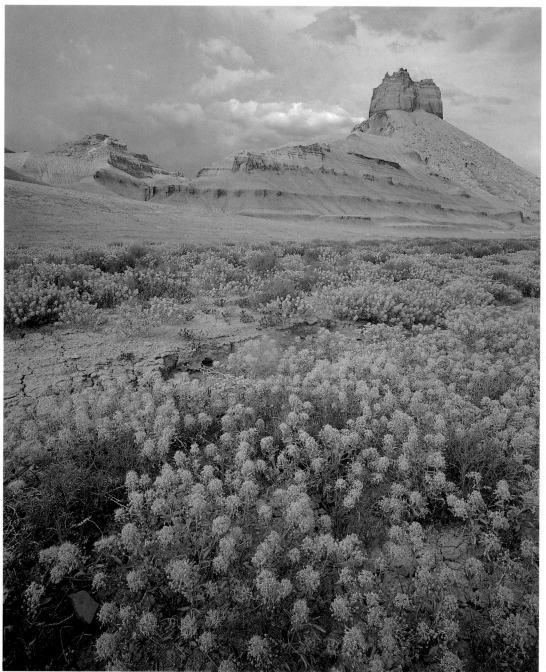

CLEOMELLA,
GLEN CANYON AREA, MAY
Sunny cleomella covers a Tropic Shale
badlands area just north of Padre Bay.

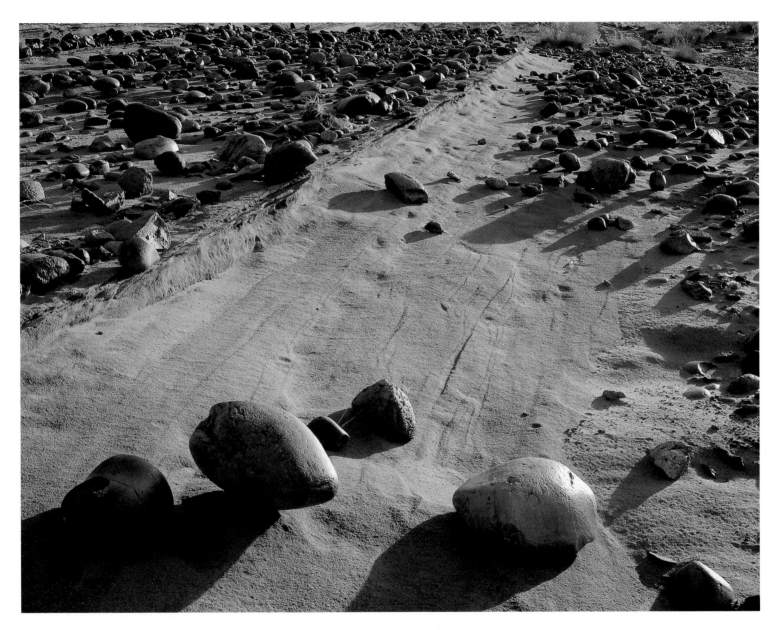

GLEN CANYON AREA, JANUARY
The Colorado River once rolled and tumbled these cobbles
from mountains hundreds of miles away, smoothed and
polished them, and arranged them on a sandstone shelf.

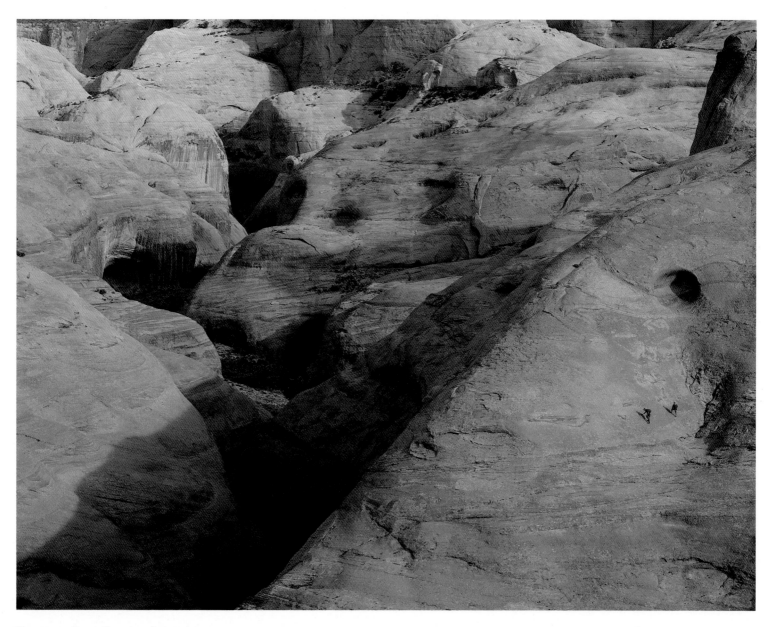

HIKING IN GLEN CANYON AREA, APRIL
Two hikers scramble across a maze of mountainous slickrock.

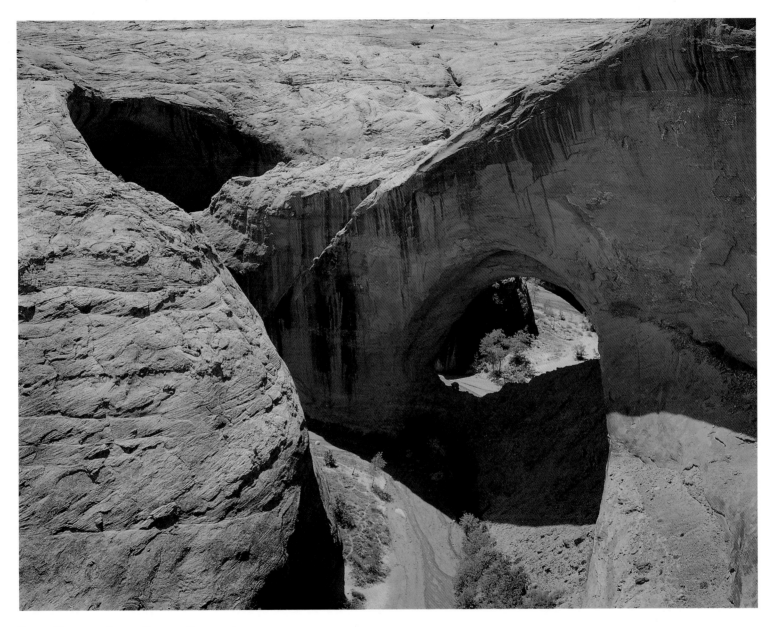

JACOB HAMBLIN ARCH, COYOTE GULCH, APRIL
"When thinking of these rocks one must not conceive of piles of boulders or heaps
of fragments, but of a whole land of naked rock, with giant forms carved on it. . . . "
– *John Wesley Powell,* Canyons of the Colorado, *1895*

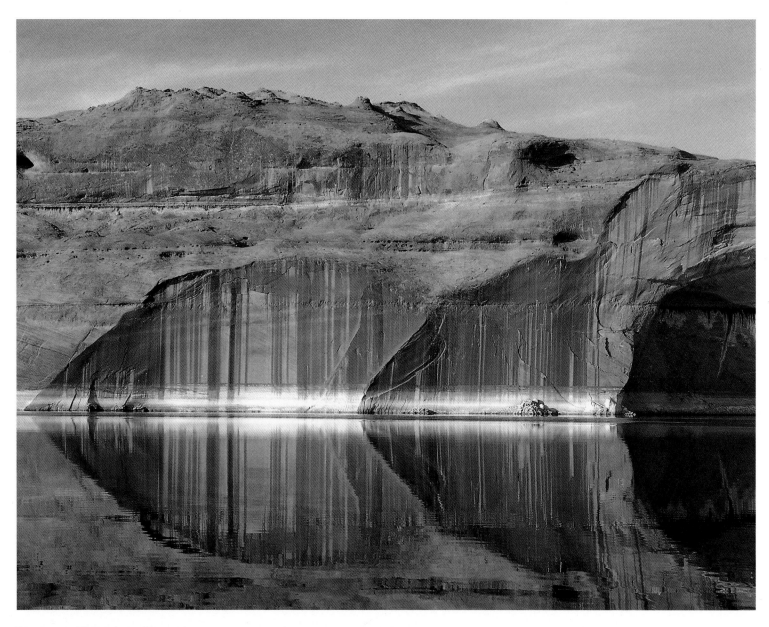

ESCALANTE RIVER ARM, JANUARY
The so-called "bathtub formation" or "bathtub ring" is not a rock layer but
a coating of minerals and plant life deposited by a higher Lake Powell. Falling
lake levels reveal a veneer of dead plants and minerals such as calcium carbonate.

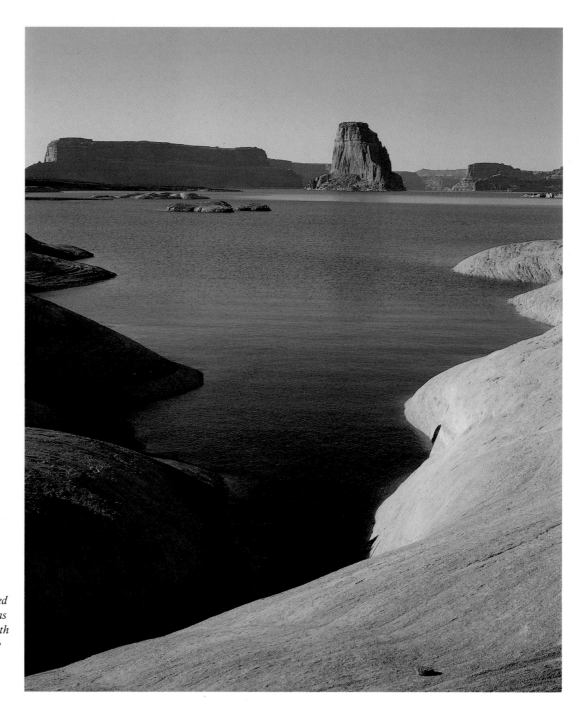

GREGORY BUTTE
AT THE ENTRANCE TO
WEST CANYON, FEBRUARY
*Gregory Butte was once called
Church Rock by river runners.
After Gregory Natural Bridge in
the Escalante Canyons was swallowed
by a rising Lake Powell the name was
transferred to the butte near the mouth
of West Canyon. Herbert E. Gregory
was a pioneering geologist in the
vicinity of Glen Canyon and the
Navajo Indian Reservation.*

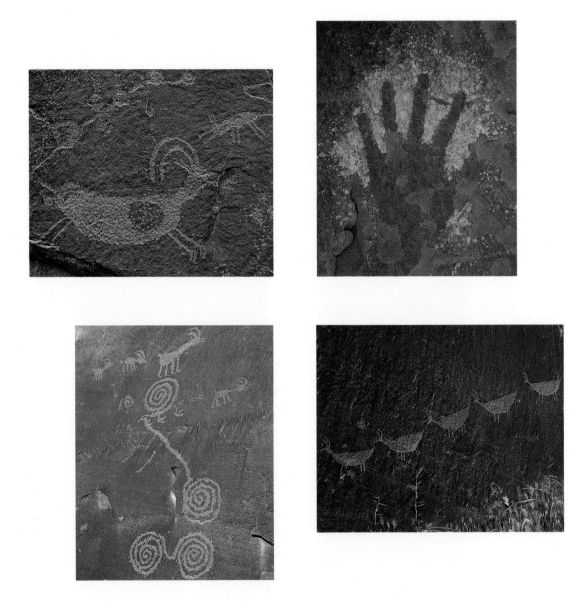

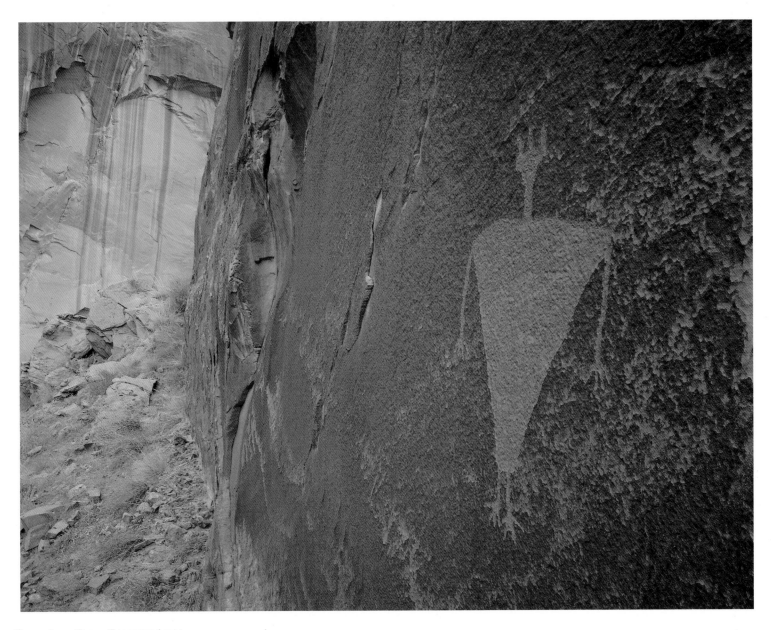

ROCK ART, GLEN CANYON AREA
The Anasazi and other pre-European inhabitants of the Southwest had no written language,
but left eloquent messages carved or painted on stone. These seem to speak of hunts, rituals,
stories of emergence or migration—signatures of long departed wanderers.

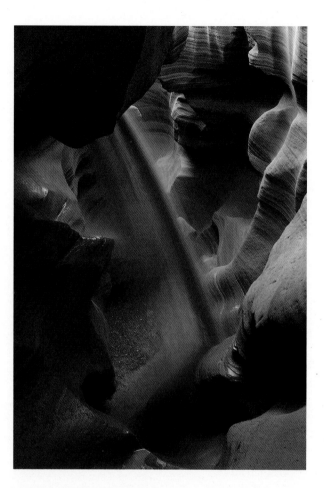

ANTELOPE CANYON, JULY
A rumbling commotion from upstream
can announce the approach of a flash flood
even if it is not raining nearby. Depending
on the severity of the storm, the size of the
drainage basin, and the condition of the land,
a flash flood can be a cute puppy or a murderous
monster. In the narrow confines of a slot canyon
ALL approaching floods throb and sound
horrendous. A hiker's heart quickly picks up
the beat. One's feet tend to do the same.

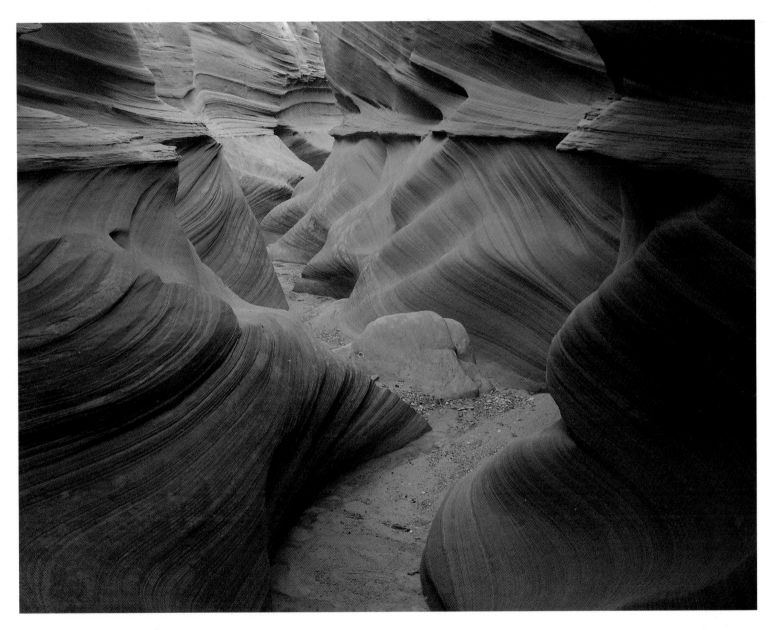

UNNAMED SLOT CANYON, OCTOBER
Swirly flash floods use boulders and cobbles carried from upstream to grind chambers from the sandstone. Most floods are short-lived, lasting only minutes to a few hours, yet their massive power is extremely effective.

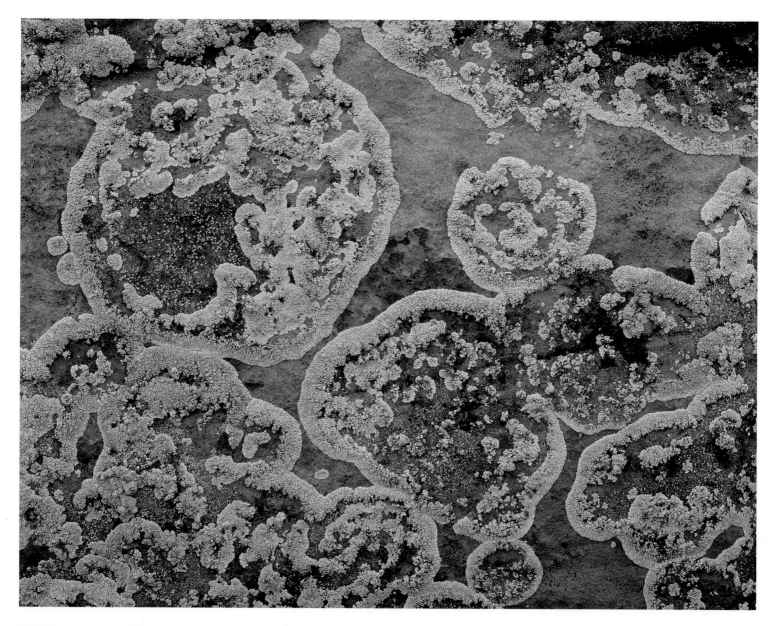

GLEN CANYON AREA, NOVEMBER
Green and gray lichen cling to Kayenta Sandstone.

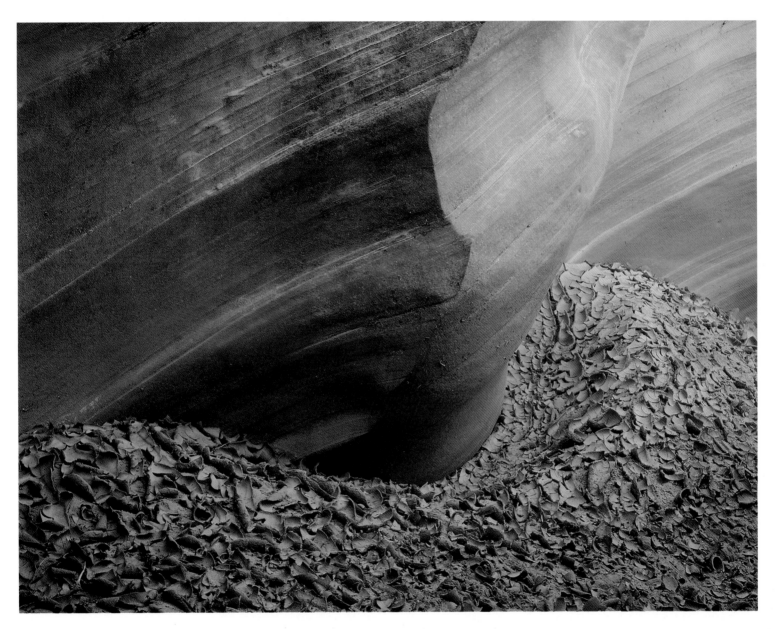

GLEN CANYON AREA, OCTOBER
*This slot canyon has received few visitors: mud, now dried and cracked
since the last spring flood, has not been pulverized by human feet.*

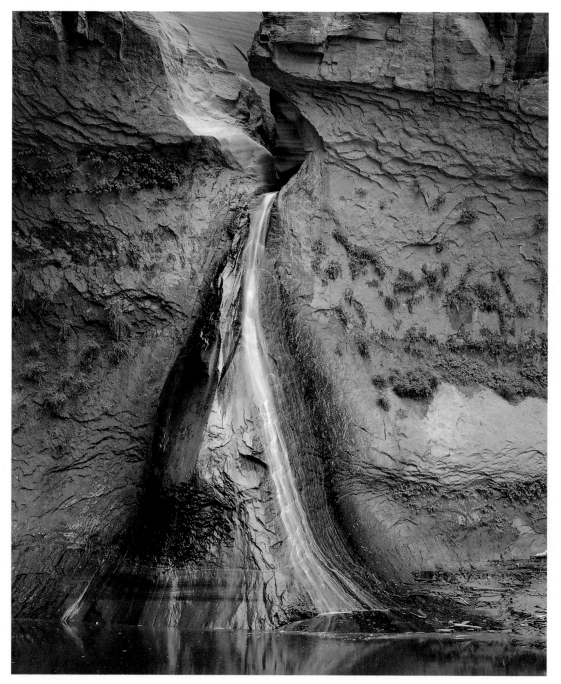

WATERFALL, LAKE POWELL
TRIBUTARY, NOVEMBER
*Coursing waters sculpt a path through
rock, then slide down an algae-slickened
backwall into a serene pool. Horizontal
seep lines also provide moisture for a
variety of plants not usually seen in the
desert. Scientists in Glen Canyon are
still cataloging botanical diversity in
these watery grottoes.*

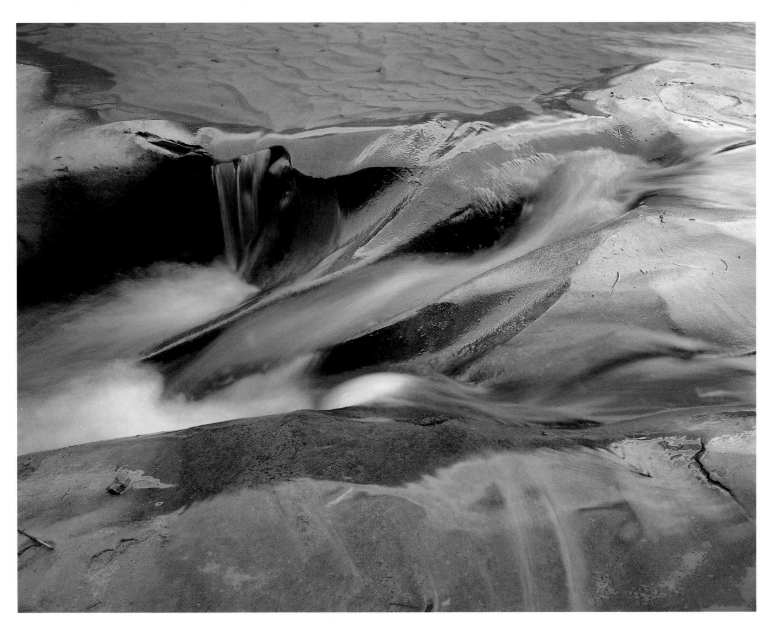

KAIBITO CREEK, MARCH
"If there is magic on this planet, it is contained in water." – *Loren Eiseley,* Visions of Wilderness

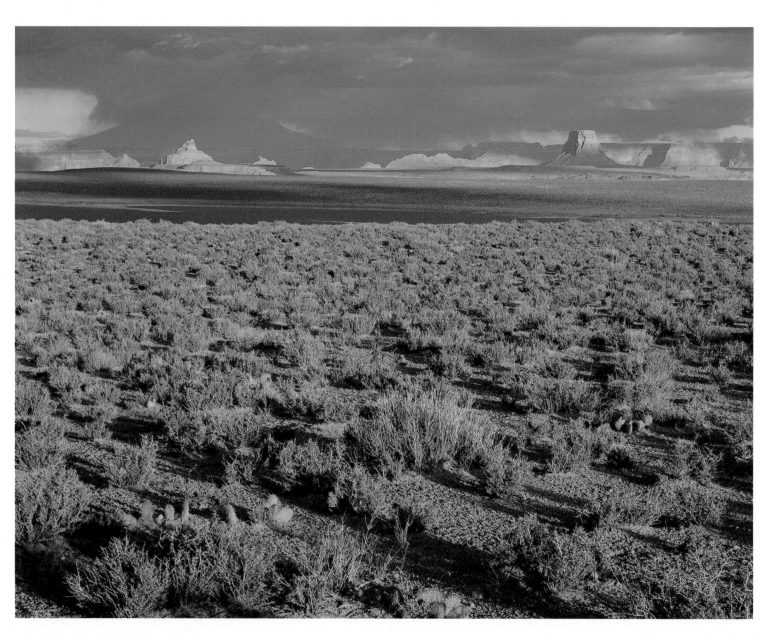

NEAR WAHWEAP MARINA, NOVEMBER
Storms sweep across Lake Powell while golden light
stains Boundary and Tower Buttes.

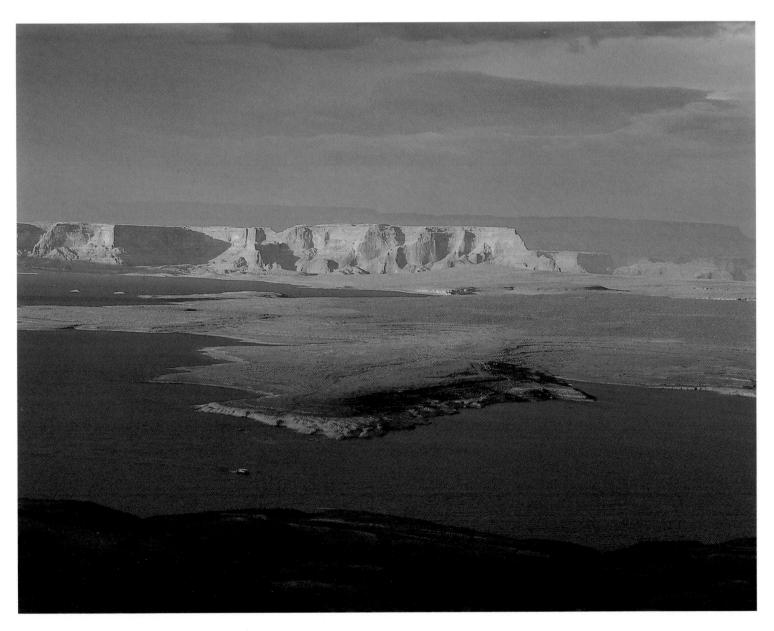

VIEW FROM ABOVE LAKE SHORE DRIVE, AUGUST
Antelope Island's tawny fingers caress azure waters.
Romana Mesa glows in the background.

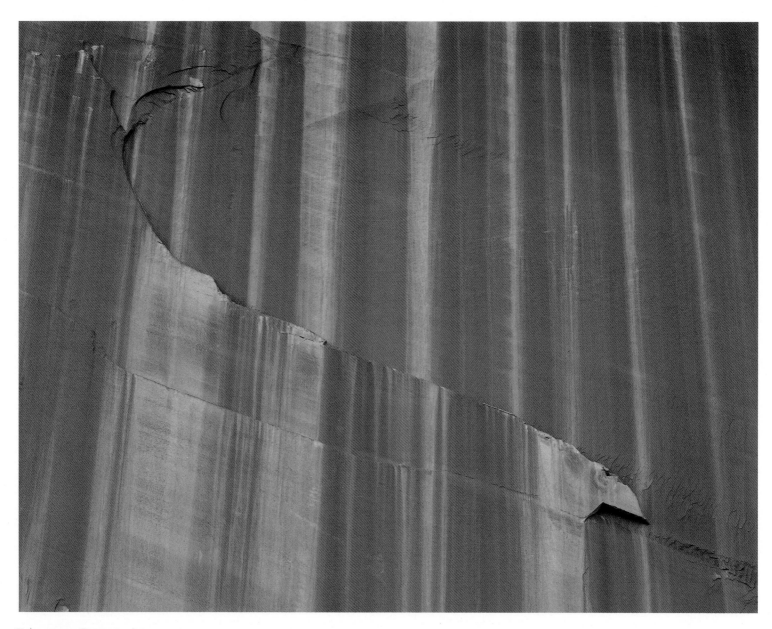

ESCALANTE CANYON, AUGUST
Desert varnish striates a wall of Navajo Sandstone.

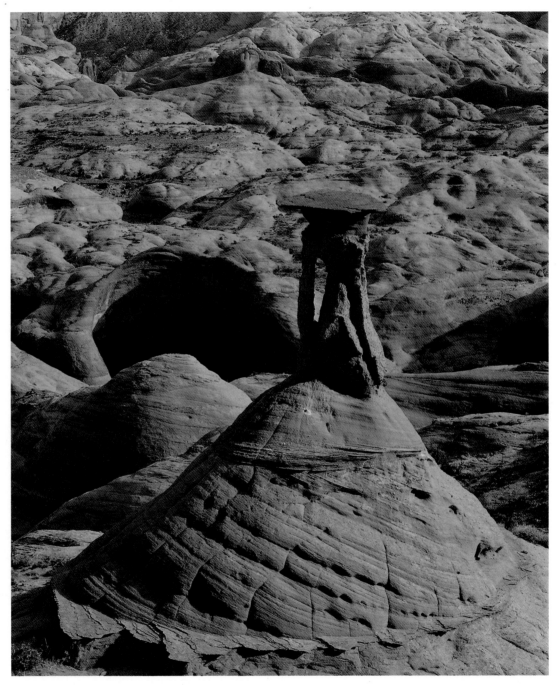

HOURGLASS ROCK, NOVEMBER
"In this land of light, rocks are
elevated to sculpture, and each
earth gesture is a work of art."
– John Telford, Coyote's Canyon

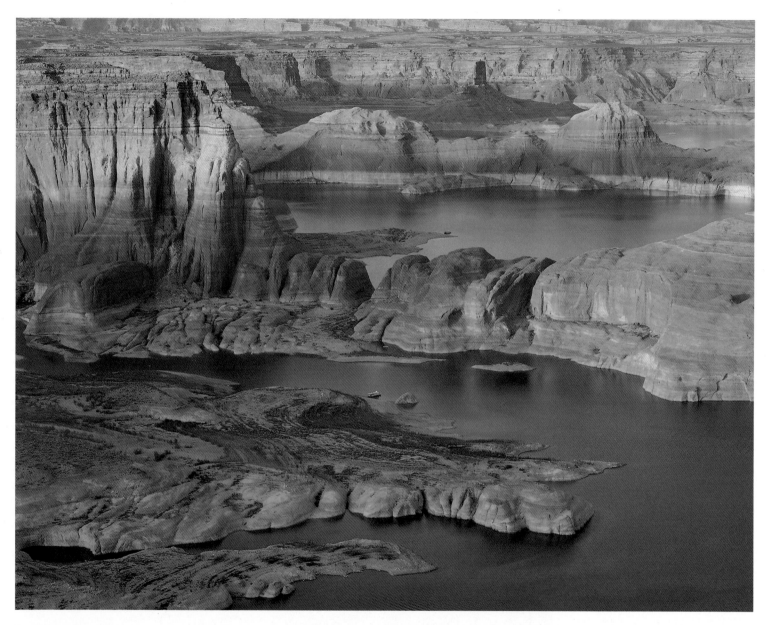

GUNSIGHT BAY, MAY

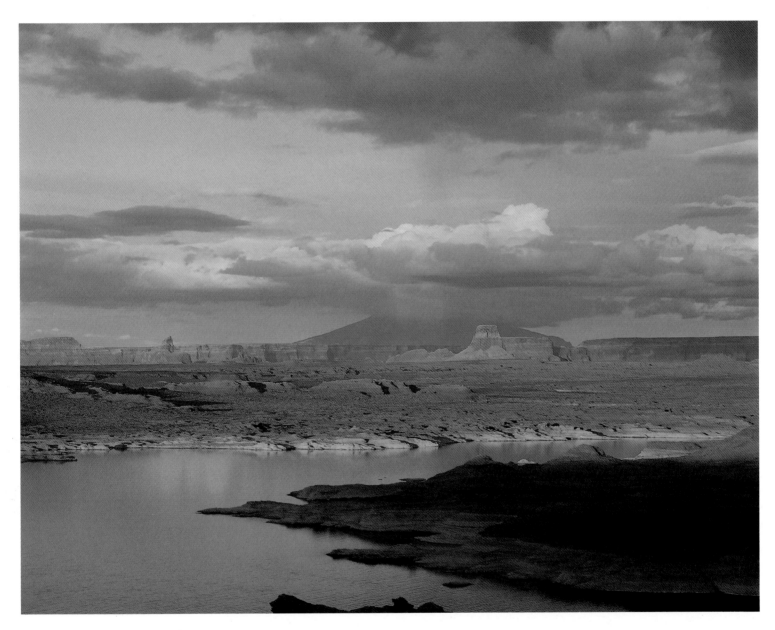

VIEW OF NAVAJO MOUNTAIN, APRIL

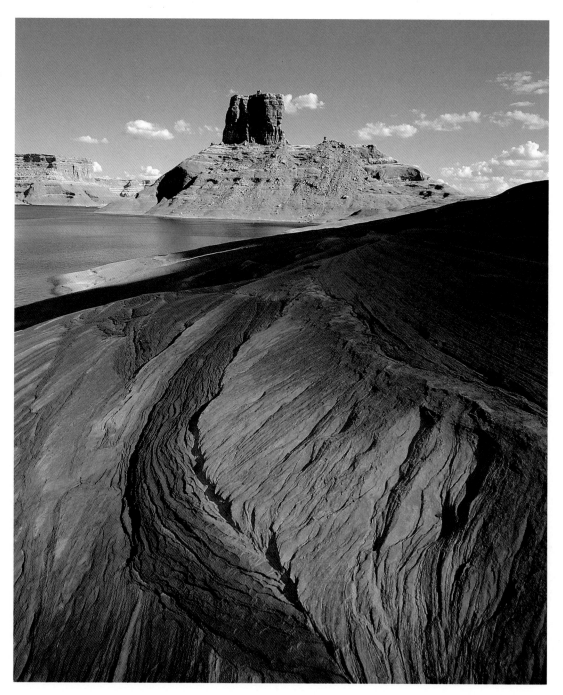

COOKIE JAR BUTTE, SEPTEMBER
Crossbedding in some portions of the Entrada Sandstone indicates, as with the Navajo Sandstone, deposition in sand dunes. The Entrada forms beautiful flowing slickrock terrain on much of the north side of Padre Bay.

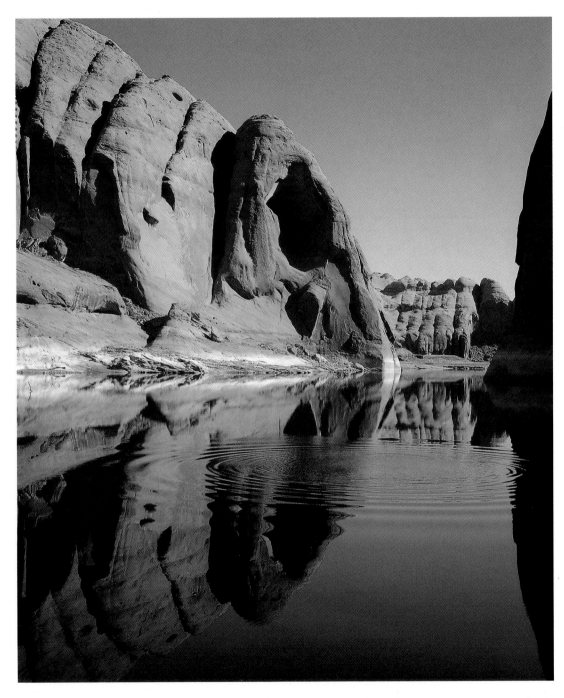

LLEWELLYN GULCH, MARCH
*Concentric rings ripple across
a liquid mirror.*

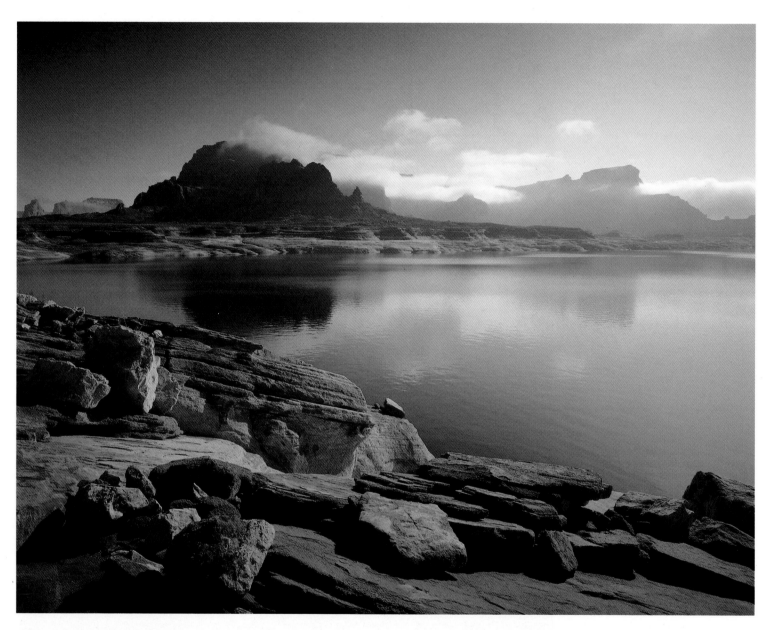

NEAR FACE CANYON, DECEMBER
Clouds play among buttes and mesas.

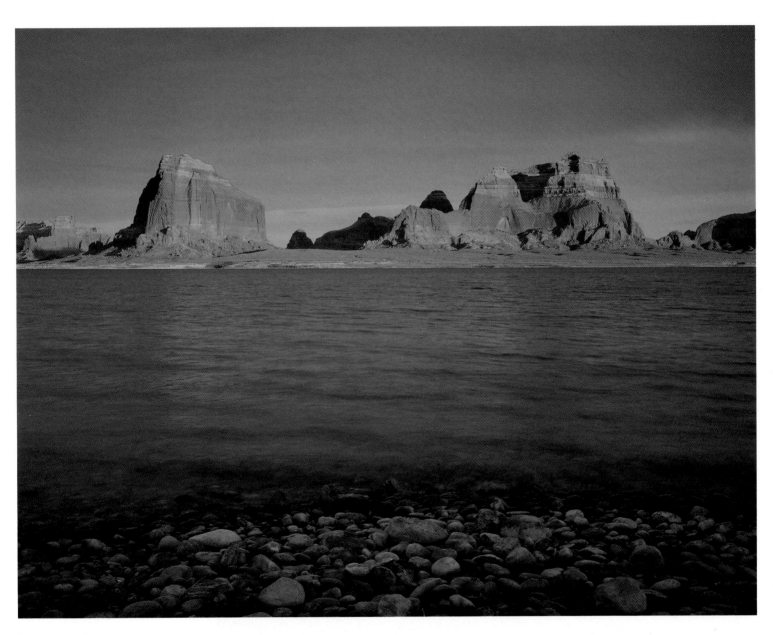

PADRE BAY, SEPTEMBER
Rock formations glow at sunset. Dominguez Butte, at left, is named
for one of the Franciscan friars who crossed the Colorado here in 1776.

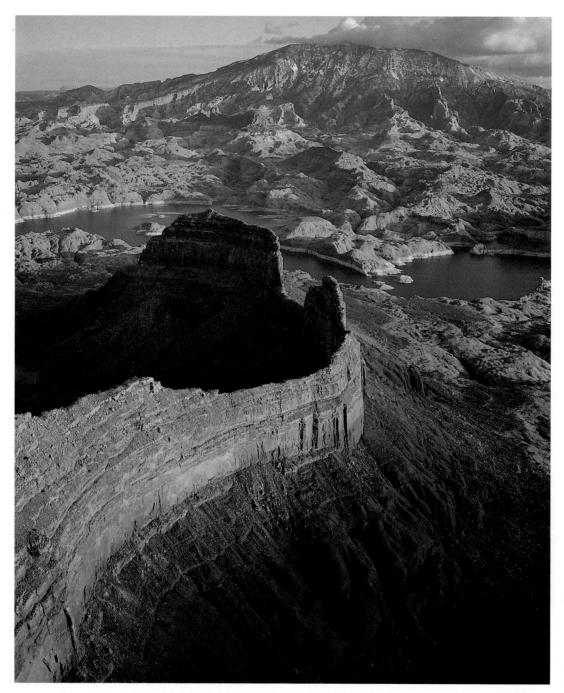

"Man has at last conquered the land.
But to what ultimate end no one can say.
There is only a vague, inquiet feeling
that in all his scheme of domination
there is something he might have
forgotten. It may well be that the river
itself will have the last word, after all."
– *Frank Waters,* The Colorado

LAKE POWELL AERIAL, MAY
*A base ridge of Kaiparowits Plateau
snakes toward Navajo Mountain.*

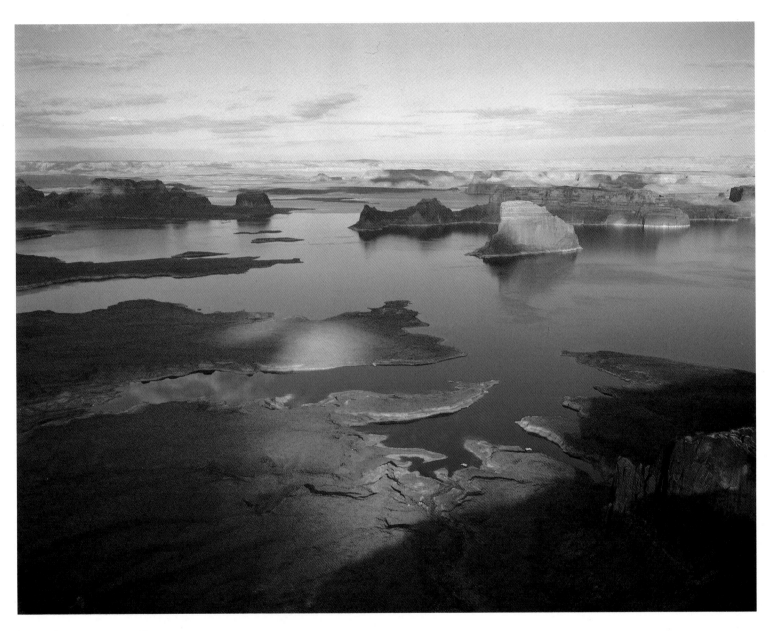

DOVE CANYON AERIAL, FEBRUARY
From the air, Lake Powell and Glen Canyon appear even more surreal. One sometimes wants to just lay down the camera and gawk. Aerial photography is both easier and more difficult: easier because there is so much to choose from, harder for the same reason.

Escalante Canyon, August
Sunset colors reflect on Lake Powell waters.

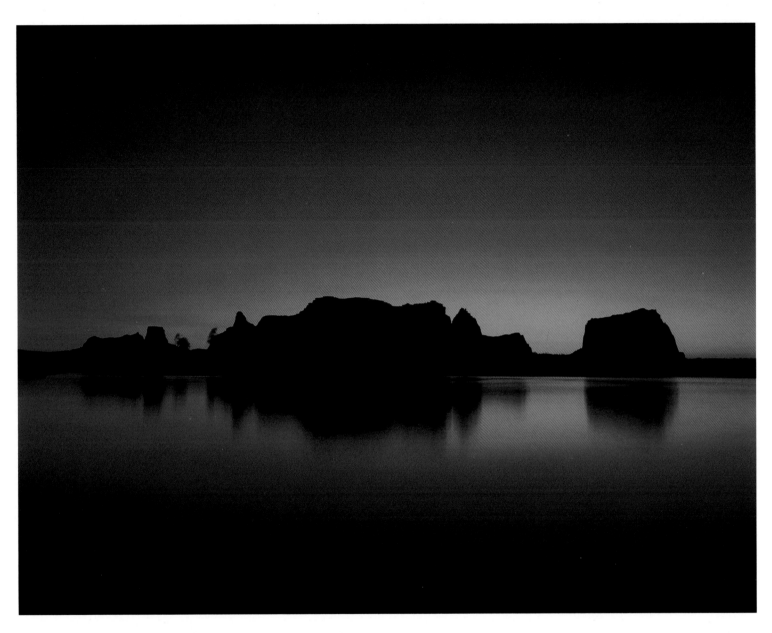

DOMINGUEZ BUTTE, PADRE BAY, DECEMBER
"There must be room enough for time —where the sun can calibrate the day, not the wristwatch,
for days and weeks of unordered time, time enough to forget the feel of pavement and to get the feel
of the earth, and of what is natural and right." – *David Brower,* A Place No One Knew